The
GRANDE BALLROOM

The GRANDE BALLROOM

DETROIT'S ROCK 'N' ROLL PALACE

LEO EARLY

FOREWORD BY RUSS GIBB

THE
History
PRESS

Published by The History Press
Charleston, SC
www.historypress.net

Front cover: "The Who, 1968." *Copyright 1968 Tom Weschler.*
Back cover, top: "The Grande Ballroom." *Copyright 2016 Manning Brothers Historic Photographic Collection*; *inset*: "Iggy Pop, circa 1968." *Copyright 1968 Leni Sinclair.*

First published 2016

Manufactured in the United States

ISBN 978.1.62619.781.7

Library of Congress Control Number: 2016948312

CONTENTS

CONTENTS

FOREWORD

Dear reader,

I first met your author, Leo Early, in 2004 after he had contacted me regarding his website about the Grande Ballroom. I was surprised that this author, musician and historian, who was far too young to have ever gone to the Grande, had such an interest in the old place. I had recently retired from teaching and was astonished that people still contacted me about the ballroom. As the proprietor and promoter of the Grande (pronounced "grand-/ē/") during the late 1960s, I was too busy living the experience to have time to document it. In this book, Early has taken care of that for us. In the years since our first meeting, Early has interviewed me many times about the phenomenon of the Grande and about my life preceding it. Although not an encyclopedia, this work is a great peek into all eras of the ballroom's operation. I was especially pleased to see the depth of research done on the owners and architects, most of which made it into this text you are holding in your hands. If you ever went to the Grande and saw the MC5 or you have heard your grandparents first met on its dance floor, you will enjoy this book. The bottom line is I know of no other title as ambitious in its documentation of what the Grande was and what it meant to so many of us.

Russ Gibb
2016

ACKNOWLEDGEMENTS

Special thanks go to: the Early brothers Tom, Dave and Dennis; Russ Gibb; Gary and Laura Grimshaw; Carl and Michele Lundgren; Leni Sinclair; John Sinclair; Dave Miller; Wayne Kramer; Tom Lubinski; Tom Gaff; Rebeca Binno Savage; Dan Austin; Susan Adams; Alyn Thomas; Ruth Hoffman; Becky Derminer; Arlene Glantz Blum; Tom Wright; Steve Kott; Rick Patrny; Frank and Peggy Bach, Michael Erlewine; Andrew Schneider; Krysta Ryzewski; Cecil Whitmire and the Alabama theater; Steve Finly; the Weitzman and Agree families; Pat Nuznov; Carter Collins; Dick Wagner; Susan Michelson; Gary Quackenbush; Ray Goodman; Benny Speer; the Fiegers; Jennifer Crum Estrada; Dr. Carleton Gholz; Stanley the Madhatter; Ron Cooke; Jim McCarty; Greg Piazza; Tom Weschler; Jim Price; Clyde Blair; Donald Early; Jerry Younkins; Jim Dunbar; Roger Craig; Emil Bacilla; Vic Peraino; Preservation Detroit; the Detroit Sound Conservancy and all the Friends of the Grande.

GENESIS

*At different points in time on this planet, there are certain places where
there is a field of energy.*
—*Jimmy Cliff*

The story of the Grande Ballroom is much more than a tale about a
building. It is also very much about a neighborhood, a dynamic city and
some extraordinary people. It is therefore important to profile the people and
events that enabled this landmark establishment to rise out of this particular
Michigan township.

1
RAVENSWOOD

Detroit's Grand River Avenue was once an Indian trail that led to the river and the French settlement of De'troit. In 1840, the old river trail was merely a muddy pair of ruts for months out of the year, as was typical for the township and young state at the time. The General Plank Road Act of 1850 spurred private enterprises in Michigan to build plank roads, provided they held to certain specifications. Towns like Redford, Farmington, Novi, Howell and Brighton all were stops along the Detroit–Howell–Lansing plank pikes. These planks serviced horse-drawn coaches, and the Grand River and Joy Road intersection was a toll coach stop exactly five miles northwest of Woodward, Detroit's main avenue. Streetcars on rails offering service within the city limits, which in 1875 was McGraw Avenue, eventually replaced the coaches.

The Joy–Grand River crossroads bordered ten thousand acres of sparsely populated farmland in 1887, when developers Albert E. Peppers, Frank C. Irvine and Charles P. Toll platted it for residential development. The group called the neighborhood Ravenswood, a marketing ploy conjuring bucolic visions in this northeastern corner of Greenfield Township. Sales of lots in this first subdivision of Detroit did not take off until city annexations reached Joy Road in 1912. With the mobility provided by the streetcars and the income from the boom years of national defense contracts and automobile production, more people sought a home farther away from the city core. Thanks, in part, to this particular enabling road, the area of Ravenswood was able to attract many of these homebuyers. A significant number of these new residents along Grand River happened to be Methodists.

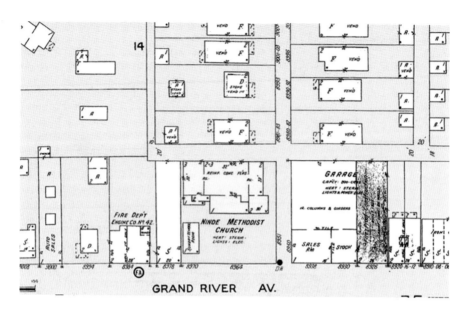

GRAND RIVER AV.

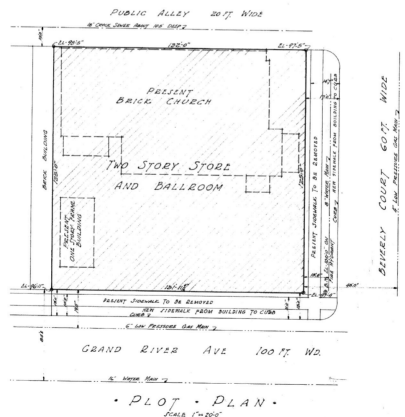

PLOT · PLAN
SCALE 1" = 20'-0"

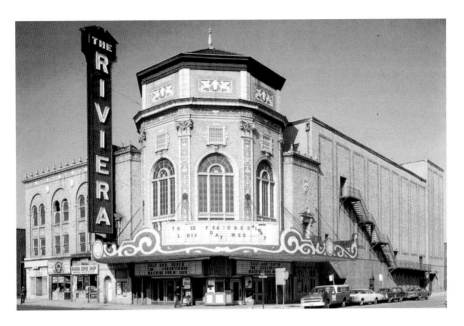

The Riviera Theater. *Wayne State University.*

Opposite, top: Ninde Methodist Church Sanborn Fire Insurance map, 1926. *Detroit Public Library.*

Opposite, bottom: Grande Ballroom blueprint land plot panel. *Charles N. Agree, architect; courtesy Russ Gibb collection.*

Around 1918, the Ninde Methodist Church was operating at the corner of Grand River (M-16) and Beverly Court. Fire insurance maps and land surveys from 1926 show a two-story brick church and a detached single-story Sunday school. These structures also appear on the architect's site survey for a new 1928 ballroom-retail building.

Within ten years, Ninde Methodist Church had merged with McGraw Methodist to form the three-thousand-member Nardin Park Methodist (1927), a beautiful, new Gothic stone church one quarter mile up Grand River from Beverly. Small businesses flourished at the crossing of Joy and Grand River at this time. Many of these merchants were then Eastside Jews who had established a significant presence in the area. The neighborhood became so crowded that it even had its own Detroit Fire Department Engine company (No. 42) at 8986 Grand River. By 1930, there were over two hundred motion picture theaters in operation in Detroit. Every busy neighborhood had to have one, and Ravenswood was no exception.

Noted architect John Eberson designed the Grand Riviera Theater at 9222 Grand River. Advertisements of the time promoted the stretch of Grand River from Joy westward to Redford Township as the "Riviera." *Riviera* is Italian for "river" or "bank." The name evoked images of exclusivity and recreation along famous French and Italian beaches. Although its water feature was a concrete one, the Great Beach or Grand Riviera opened in August 1925 with three thousand seats. It soon became so popular that its owners built the Riviera Annex Theater just down the street at 8990 Grand River to handle the overflow. Debuting in February 1927, the Annex was well timed, as demand was about to explode with the advent of sound on film. By 1928, the neighborhood had over four thousand theater seats and a 1,500-person-capacity ballroom.

2
THE WEITZMANS

The original owner of the Grande Ballroom was a colorful character, one worth profiling in detail for his accomplishments, escapades and historical significance. Harry Weitzman was the second-eldest son of Russian Jewish immigrants Jacob (1858–1925) and Esther (1855–1927) Weitzman. Hardworking merchants, they found opportunity in the Midwest, enough to provide a home and a stable upbringing for Harry and his siblings.

HARDWARE

Jacob and Esther Weitzman had one daughter, Rose, and four sons: John (born in 1881), Harry (born in Buffalo, New York, in 1884), Louis (born in 1888) and Benjamin (born in 1892). The family started their own small business, Weitzman hardware, located at 723–25 Gratiot Avenue at the dawn of the auto age. The near Eastside was an early enclave of Jewish immigrants and merchants that produced many notable Detroiters. Weitzman's was, for decades, a landmark amid this community. The Weitzmans' second eldest, Harry, proved to be exceptional at business. Early on, he exhibited promise as a young entrepreneur.

In 1909, twenty-five-year-old Harry Weitzman married nineteen-year-old Lillian Levey, who was of Jewish and Polish ancestry. Together they had three children: Clement (C.J. or Clem, born in 1911), Dorothy (Dotsie, born

Clement Weitzman. *Courtesy Rabbi Leo M. Franklin Archives.*

in 1914) and Seymour (S.T., Teek or Seek, born in 1916). Harry and Lillian lived at 349 Hurlbut Avenue on the Eastside by 1914, and real estate development had become one of a series of collaborations Harry started with Barney "Buck" Schroeder.

By 1918, Harry was running a jewelry and loan shop, Weitzman Jewelry, at 85 Woodward Avenue with his brothers Ben and Louis. Next door at 87 Woodward, Harry operated the Maryland Bar, a pre-Prohibition saloon with Schroeder and another partner, Dave Zubor.

Harry's son Clement recalled that as a small boy, he rode the Woodward streetcar downtown once a week. He visited his uncles and father at their jewelry shop but never the saloon, which was always filled with city and county government types. Clem Weitzman graduated Highland Park High in 1929 and later attended the Detroit College of Law.

PROHIBITION

On May 1, 1917, the Damon Act went into effect in Michigan, prohibiting the sale of alcohol some twenty months before Congress ratified the Eighteenth Amendment on January 29, 1919. This decree spelled the end for Weitzman's popular Maryland Bar. Although Harry appeared diversified enough for this not to matter much, over time stories began to circulate detailing his uninterrupted operations. On August 25, 1919, the *Free Press* reported a major raid on the Maryland Bar:

Police Seize Bar, Jail 4 Employees—Several thousand spectators watched the police cleanup squad Sunday afternoon as it removed the Maryland bar almost bodily from the premises at 87 Woodward Ave. to the police barns. A large crowd of men was drinking in the place when the cleanup squad arrived the police reported. The four held were Michael Quinn, John Fray, John Maclein [Marklein] *and Harry Spillman* [likely Weitzman].

Although the paper did not accurately report his name, Weitzman and his partners were apparently diluting and selling booze illegally from the Maryland. The police found, along with forty quarts of liquor, several hundred pint bottles partly filled with water. On March 15, 1922, Harry and his crew were still at it, this time with a mobile operation. The front-page *Free Press* headline read, "Detroit Police Halt Public Auction of Booze in Street—Whiskey sold openly from automobile. 105 quarts were seized when officers swoop down on sellers, bidders. Crowd flees at sight of uniforms; alleged car owner, four others arrested."

Evidently, Harry and his crew were auctioning off American whiskey from the running board of his car. Charged with violation of the state liquor law were Weitzman, along with his Maryland Bar partner Buck Schroeder. As at the Maryland three years before, this pre–St. Patrick's Day street sale was less than discrete. "Few attempts, it is alleged, had been made at secrecy," reported the paper.

The group members certainly were not slumming, as they had parked at 354 Lennox Avenue, just across the street from 384, where auto magnate Lawrence Fisher built his mansion in 1927. This neighborhood was where other famous industrialists, such as hydroplane champion Gar Wood, built even more fabulous homes. The development, known as Grayhaven, surrounded a famous inlet of the Detroit River.

In the 1920s, bootlegging arrests generated a windfall for attorneys and other businesses related to the courts. To exploit this opportunity, Harry Weitzman, according to his son Clem, started his brother Ben off in a surety bonds business. Eventually (about 1930), the Direct Bonding and Insurance Agency opened offices on the fifth floor of the Free Press building. The family already had substantial connections with Detroit's legal system from the Maryland Bar, and they got a sizable share of bonding referrals from this network. A cousin, Lewis Weitzman, an orphan raised by Harry, was an assistant prosecuting attorney and may have steered clients their way. Bruce Finsilver, Ben Weitzman's grandson, attests that his grandfather "became the personal bail-bondsman to the Purple Gang." Harry's brother Louis,

the jeweler, died at the young age of thirty-seven in 1925. Other Weitzman descendants recall that the brothers knew, and did indeed do business with, members of Detroit's underworld.

THE BIG SCORE

Harry knew mobster Benjamin "Bugsy" Siegel and, from a young age, was a habitual gambler. He eventually became a high roller and possibly a bookmaker. In 1909, on his honeymoon trip to Florida, "Harry was able to completely furnish their first home with $20,000 won at blackjack on the return train trip," his granddaughter Annie Weitzman explained. Annie related that he "loved the thrill of gambling and he loved to drink." His son Clem noted while describing his father's legitimate businesses that "all this was fine, but his main business was the gambling."

A major windfall in 1926 became legend and likely further elevated his society profile and street credibility. An article in the *Detroit News* on Tuesday, January 13, 1942, told the story, which occurred on Armistice Day in 1926, of how Harry Weitzman walked in to a blind pig run by famed Macomb County gambler Danny Sullivan. After an all-nighter of shooting craps and drinking champagne from water pitchers, Harry walked out with a cashier's check for $115,670 ($1,583,030 in 2016 dollars).

Weitzman Famed as Winner of $100,000 from Sullivan

Sullivan said, "We paid him the next day by cashier's check, and he was laughing like he was enjoying a big joke....He made a remark I never forgot. He said 'Thanks Sucker.' But Harry Weitzman was no sucker. He won a fortune and he never came back. He sure was a great gent."

After Prohibition became law, Harry Weitzman's business focus appears to have shifted from running a bar and pawnshop to real estate investments and the other enterprises involving his brothers. In six years, Detroit and Windsor had become a major bootlegging pipeline, and Weitzman and company were sitting astride it.

TOMMY'S BAR

During Prohibition, there were easily hundreds of speakeasies operating within the city of Detroit. One such speakeasy was Tommy's Bar, a favorite haunt of the infamous Purple Gang today called Tommy's Detroit Bar and Grill at 624 West Third Street; it is but a few hundred yards from the river. Known for their bootlegging activity both on and off the water, the Purples controlled a significant portion of the booze coming out of Canada.

In Tommy's basement today, you can see evidence of tunneling, a hidden room and a secret entrance, hallmarks of an illegal operation. Harry Weitzman happened to gain ownership of Tommy's through his jewelry and loan business. The *Detroit Jewish News* quoted Wayne State University's Professor Krista Ryzewski: "Weitzman acquired the property from an Italian man named Louis Gianetti when he couldn't pay back his loan. He ran the bar from 1927–1933, during the peak of the Purple Gang activity. It does seem that he was the host at a lot of venues where the Purple Gang were known to hang out."

LITTLE HARRY'S

The Alexander Chene House was one of Detroit's oldest buildings. Built in 1855 on land granted the Chene family by Louis XIV of France, Little Harry's was located at 2681 East Jefferson. The Federal-style restaurant and piano bar was as popular with the Purple Gang as it was with the yachting crowd. Close to Belle Isle and the Detroit Yacht Club, it drew a large wealthy clientele, most of it from the Eastside suburbs along Lake St. Clair like Grosse Pointe and St. Clair Shores. According to Krista Ryzewski, "It is believed, but not confirmed, that 'Little Harry' was Harry Weitzman." Here its owner played host to mariners, mobsters and moguls alike in an upscale, legitimate restaurant where patrons might enjoy some hard-to-find refreshments. On the subject of Weitzman's business connections, Ryzewski told the *Detroit Jewish News*, "What's strange, though, is that in 1931, after the infamous Collingwood Massacre, in which members of the Purple Gang killed three members of the rival Third Street Gang, Weitzman can be found in the historical record brokering deals and doing business under the alias Harry Saderno, an Italian last name. If you're going to cover your tracks, especially your relationship to the Purple Gang, you should change your name."

FINAL HOME

By 1930, Harry and Lillian had moved to a stately home at 1150 Boston Boulevard. The Boston Edison district was home to many auto magnates, lumber barons and city officials. Harry lived here until 1942, when he died of a thyroid condition at the age of fifty-seven. According to his *Detroit News* obituary, he had been ill for several months. It continued, "He never turned down a request for a loan from a needy person." Friends claimed that "he gave liberally but very quietly to numerous charities." Detroit's verdant Woodmere Cemetery is Harry's final resting place. His widow, Lillian—who later married Lou Rosenthal, who ran Rosenthal's Hardware in the 1950s at the Grande building—is buried beside him. At the Grande Ballroom, cast in stone beneath a couple of the windows, is Harry's dedication to his children. In old gothic script are the first initials of the first names of his children, Clement, Dorothy and Seymour Weitzman: CDSW.

DESIGN FOR FUNCTION

In the late 1920s, Detroit was overwhelmed with new construction projects. Its population explosion had generated a need for new housing and venues of entertainment. The Petoskey-Otsego, aka Ravenswood, district was especially well suited for both retail and amusement establishments. It was here, near the intersection of Grand River Avenue and Joy Road, that Harry Weitzman and his developers employed some of the brightest architects the Midwest had to offer.

CHARLES N. AGREE, ARCHITECT-ENGINEER

Grande Ballroom architect Charles Nathanial Agree was a contemporary of Chicago architect Frank Lloyd Wright and the legendary Detroit architect Albert Kahn. True innovators, Agree and Kahn helped raise the modern city of Detroit.

Agree was born on April 17, 1897, in Petropavlovsk, Russia, to parents Isaac and Rachel Agree. The 1905 Revolution was a period of concerted unrest and danger for those Russians of the Jewish faith, and Charles and his family likely immigrated to the United States around this time. Charles attended elementary school in Stamford, Connecticut, and later Detroit public junior high

Charles N. Agree. *Courtesy of the Burton Historical Collection, Detroit Public Library.*

and high schools, graduating from Cass High in 1915. Agree's biography indicates that he was a very industrious student. At Cass, Charles interned with at least three different architects, including W.E.N. Hunter and Fred

Swirsky. Agree was fortunate to miss the first rounds of the draft for World War I. However, he did serve as a private in the U.S. Army Engineer Corps. Upon discharge, he attended the University of Michigan for a brief time. Charles told historic preservationist Greg Piazza in 1980, "I went to Cass High and then the University Michigan but I didn't get the degree. That's how I started."

THE BOOK TOWER

In 1919, Charles Agree and Associates opened for business on the eleventh floor of the Book Tower overlooking Washington Boulevard. Charles quickly went to work designing dozens of apartment blocks for his clients. The firm promoted efficient designs that maximized the use of a property's lot dimensions.

The *Detroit Free Press* ran an ad for Charles Agree and Associates on July 3, 1930:

> *In these offices on the 11th floor of the Book Tower there is another group of men you know. They are architects, dreamers, Brains and pencils, paper and understanding, a love of homes and arithmetic, these are their tools and with these and you, they make apartment homes, famous apartment homes. Go to tell them what you want, and, soon, the brooms, chessboard, books, golf sticks, coal hod and dishes, boys, girls and you are grouped in rooms in drawers and closets and corners—and you say "oh, boy!" Soft as a prayer. They wanted clients and peace of mind and they found it here. They wanted spirited neighbors and found them here. They wanted a beautiful business home and they built it here, on the 11th floor, of the Book Tower. When are you coming? We'd like that, too.*

In the 1980 interview, Charles Agree recalled the tremendous amount of revenue the firm generated from the outset:

> *From 1919 until 1929, 10 years all I was pushing out was apartments, one right after the other. I turned down everything except the apartment houses. I was specializing….I made myself a specialist by turning down when people came with theaters or Ballrooms or anything like that. I did so many apartments in my day.…In 1927 I did $10 million worth of construction. Do you know what that means in today's figures? [$136,857,471 in 2016]…We used to get out an apartment a week out of that office.[1]*

Book Tower
advertising
art, 1930.
From the
Detroit
Free Press.

THE WHITTIER TOWERS, 1926

The Agree firm's efforts to fill Detroit with apartment blocks resulted in the design of a number of notable luxury apartment hotels. Residences of this kind were becoming fashionable during the Roaring Twenties. One of these properties was the Whittier, a fifteen-story project at 425 Burns Drive in Detroit. The firm received much praise for this design because Agree was able to solve the problem of building on swampy riverfront property. Agree consulted Japanese engineers and architects who had used innovative concrete foundations for the Imperial Hotel Tokyo.

Agree later recalled the keystone property that supercharged his career: "I was pretty famous because the Whittier was one of the big apartment hotels that went up and I got quite a bit of publicity out of that.…In the first place I was young man; I was about 26, 27 years old at the time.…I did other apartments besides, of course, but the Whittier was my big chance."[2]

Not yet thirty years of age, Agree did indeed rocket to fame with the completion of the Whittier. The building was a crowning achievement for

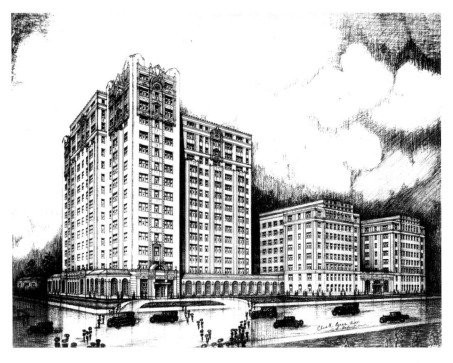

The Whittier Towers, 1926. Charles Agree, architect. *Courtesy of the Burton Historical Collection, Detroit Public Library.*

Agree and his firm after seven years of being in business. On June 6, 1926, the *Detroit Free Press* took note of the prestige. "The characteristic individuality of the Whittier stamped the architect as a leader in the nation's apartment and residential hotel designers, despite the fact that he still is in his 20's." The National Register of Historic Places listed the Whittier in 1985.

THE BELCREST APARTMENTS, 1926

The Belcrest Apartments at 5440 Cass Avenue towered over the future Wayne State University (WSU) campus. Today, students and faculty enjoy

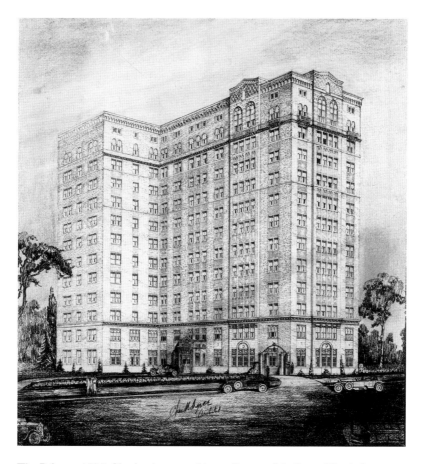

The Belcrest, 1926. Charles Agree, architect. *Courtesy of the Burton Historical Collection, Detroit Public Library.*

the inventive designs of what was at the time a novel approach to city living. Long gone are the maids, valets and concierge. Still, much of the original décor exists. The Belcrest joined the National Register of Historic Places in 1985.

THE SEVILLE APARTMENTS, 1926

Agree was awarded the contract for the Seville luxury apartment block on Second Avenue through his association with theater operator Abe Cohen. Cohen told the *Free Press*, "I have the greatest admiration for Mr. Agree. This building represents what I consider the highest perfection in apartment hotels and the architect is entitled to much of the credit." "Complete hotel service will be maintained, with night and day telephone and elevator service. Maid and valet service will also be provided. There will also be a barbershop, beauty parlor, tailor shop, drugstore, commissary and dining room making the building, in fact, a city within itself."[3]

Carved and cast-stone architectural elements were a hallmark of many of Agree's designs, elements evidenced in many of his most notable properties. Cohen's Seville concluded a trilogy of major luxury apartment projects for Agree, and the duo's relationship paved the way to a new type of commission for the firm.

GRAVEN AND MAYGER

GODFATHERS OF THE GRANDE

In addition to owning a sizable portfolio of apartment buildings, Abe Cohen and his sons Benjamin and Lou were in the theater business. The Cohens' Detroit Theatrical Enterprises owned and operated a number of exhibition houses, including the Colonial, Coliseum, Grand Victoria, Rex and Globe. When it came time to plan their largest, most ambitious neighborhood theater, the 3,400-seat Hollywood, they went directly to Charles Agree. "They had this land on Fort Street so they wanted to build this theater, old man, Cohen, Abe Cohen. He insisted that he won't let them go to another architect. I had no experience in theaters at all because my stuff was all apartment house work that I was doing. So here I had a theater

Anker S. Graven, architect. *The Edward Rupinski Collection; courtesy Andrew Schneider.*

Arthur S. Mayger, architect. *The Edward Rupinski Collection; courtesy Andrew Schneider.*

on my hands and I didn't know what the hell to do with it!"[4]

Having never designed a motion picture theater, Agree wisely decided to leverage other firms and talent to accomplish the Hollywood project. With the idea of first subcontracting the work, Agree went to John Eberson (the Grand Riviera architect) and Rapp and Rapp, two prestigious theater firms in Chicago. At the latter, he met two young architects who were eager to start out on their own. "They were good theater people; they knew the business. I made a deal with them; they would have a partner but they [would] come to my office in Detroit."[5]

Therefore, it was in the spring of 1926, after spending ten years with C.W. and G.L. Rapp, Anker S. Graven and Arthur Guy Mayger started their own Chicago-based firm with the help of Agree.

THE HOLLYWOOD THEATER, 1927

Charles Agree/Graven and Mayger

Once set up in business, Graven and Mayger wasted no time in starting work on their first two theaters: the Hollywood and the Alabama. At the Hollywood, Graven and Mayger were responsible for the interior spaces. The collaboration completed the massive 3,400-seat Spanish Renaissance structure for Agree's clients the Cohens in 1927. Ultimately, the stock market crash of 1929 obliterated most of its promise, and the Hollywood never

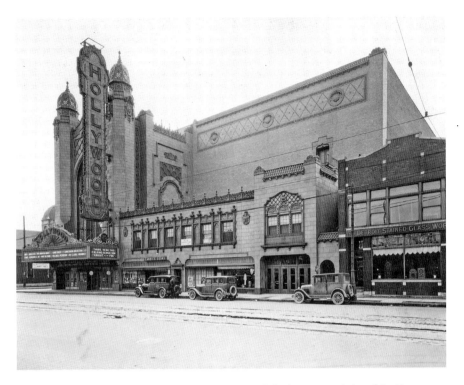

The Hollywood Theater, 1927. *The Edward Rupinski Collection; courtesy Andrew Schneider.*

amounted to more than a marooned neighborhood theater, as opposed to a major palace in new Detroit's imagined mega-downtown of the future.

Between the years 1927 and 1928, there were projects developed concurrently by Charles Agree and Graven and Mayger that shared many design elements. Although the level of interaction between the two firms was never recorded in detail, we can detect certain amounts of intellectual cross-pollination when considering some of their surviving artifacts and buildings.

The Alabama Theater, 1927

Graven and Mayger

The firm of Graven and Mayger was extremely productive from the start. It even contracted with the Paramount/Publix chain for a number of theaters outside of the Midwest. Designed and constructed concurrently with Detroit's

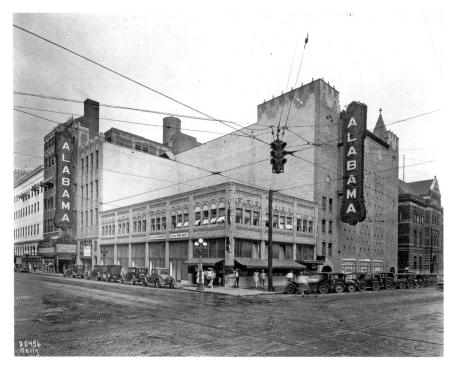

The Alabama Theater, 1927. *The Edward Rupinski Collection; courtesy Andrew Schneider.*

Hollywood, the 2,500-seat Alabama in Birmingham took eight and a half months to complete at a cost of over $1.5 million. The Alabama became one of the first public buildings in the state to feature air conditioning. Its design was primarily Spanish/Moorish, with many European crests and other heraldry featured throughout. Organist Cecil Whitmire and the Alabama chapter of the American Theatre Organ Society saved the property from the wrecking ball in the 1980s. Its exceedingly rare Wurlitzer pipe organ, nicknamed "Big Bertha," is still a centerpiece of the theater.

The State of Alabama placed a historical marker on the sidewalk in front of the theater; it reads:

> *Built by the Publix Theater division of Paramount Studios, this movie palace opened on December 26th 1927. The Theatre, in Spanish/Moorish design by Graven and Mayger of Chicago, seated 2500 in a five story, three-tiered auditorium. Paramount's president Adolph Zukor named it the "Showplace of the South." The famous "Mighty Wurlitzer" pipe organ, with 21 sets of pipes, was played for many years by showman Stanleigh*

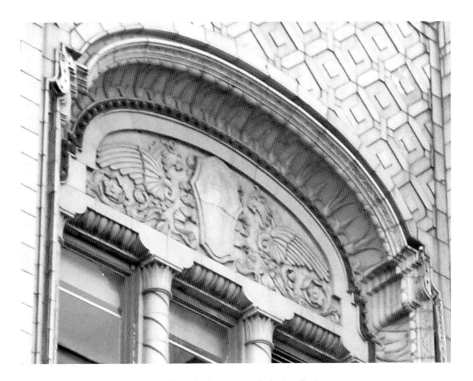

Alabama Theater cast-stone griffin window crest. *Author's collection.*

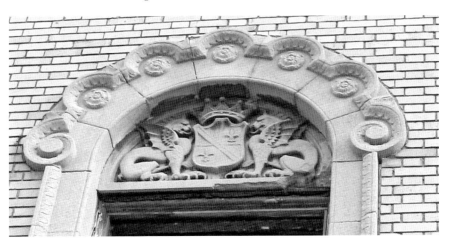

Grande Ballroom cast-stone griffin window crest. *Author's collection.*

Malotte. The Alabama hosted many events including the Miss Alabama Pageant and the Mickey Mouse Club. Closed in 1981, the magnificent old theater was saved from demolition in 1987 by countless volunteers

organized as Birmingham Landmarks, Inc. It was placed on the National Register of Historic Places and was designated by the Alabama Legislature as the official State Historic Theater. Over 500,000 annually visit the grand old theater for movies, concerts, opera ballet, weddings, graduations and private parties.

Graven and Mayger's Alabama featured elements that appeared one year later in Charles Agree's Grande Ballroom design. Most notable are the use of the cast-stone hybrid griffins or sea dragons. Agree regularly contracted the work of famed Detroit artist Corrado Parducci, and it has been speculated that these designs came from his studio. Parducci replicated his original carved master models with molds. Detroit architectural history expert Rebecca Binno Savage explained why: "Most reliefs were cast stone and that way could be economically duplicated and then installed around the building and thus look exactly the same."

THE TENNESSEE THEATER, 1928

Graven and Mayger

In 1928, Graven and Mayger approached the Paramount-commissioned 1,500-seat Tennessee Theater in Knoxville as a sort of "mini Alabama." At roughly half the size of its Birmingham cousin, the Tennessee is also the official theater of its home state. Most recently, the Tennessee underwent a $30 million restoration and, today, hosts many large touring stage shows and musical acts.

THE GRANDE BALLROOM, 1928

Charles Agree

Conceivably, in 1927, Weitzman may have approached Agree and developers Edward Strata and Edward Davis to design and build a new multiuse building. Family members believe that Weitzman also owned the Grand Riviera, which is perhaps the source of the Grande Ballroom name.

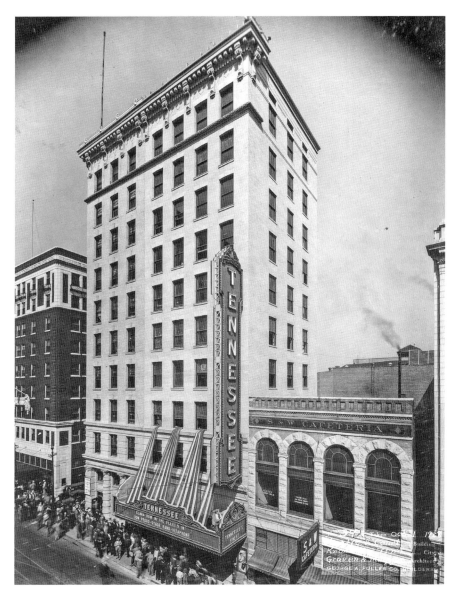

Opening night at the Tennessee Theater in Knoxville, October 1, 1928. *The Edward Rupinski Collection; courtesy Andrew Schneider.*

The owners evidently made an effort to either align or separate the two properties' similarly named marquees. Consolidation of the naming was more likely than competition. In May 1928, Agree published plans for the ballroom. Construction began immediately thereafter.

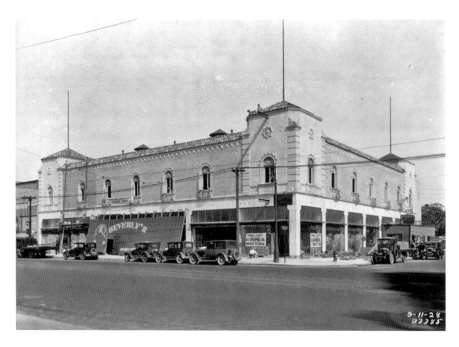

The Weitzman Building under construction, September 11, 1928. *Russ Gibb collection.*

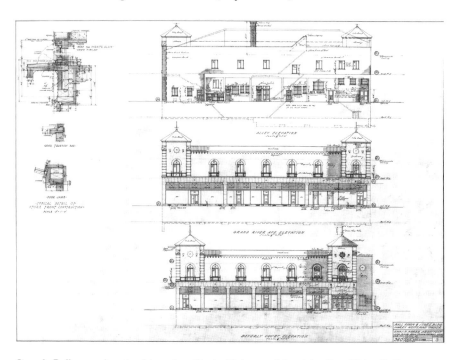

Grande Ballroom elevation blueprint. *Charles N. Agree and Associates; Russ Gibb collection.*

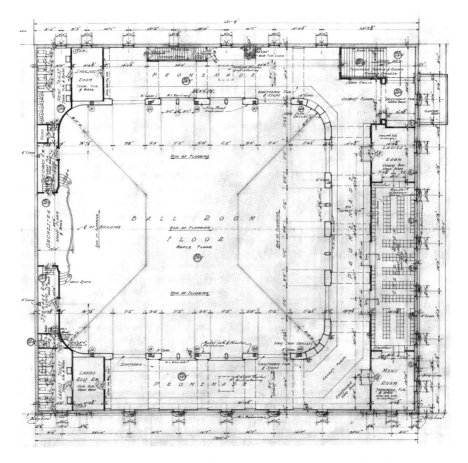

Grande Ballroom second-floor blueprint. *Charles N. Agree and Associates; Russ Gibb collection.*

Situated at the intersection of Grand River Avenue and Beverly Court, the building drew immediate interest. The new charter businesses included Economical Drugs (later Cunningham Drugs); A.E. Burns Shoes; W.T. Grant Department Store, whose retail space included a basement and mezzanine level; and the Beverly Dress Shop.

A.E. Burns Shoes held its grand opening the weekend of October 19 and 20, 1928. As of that date, the Grande Ballroom blade marquee had yet to appear. A banner hanging over the construction site on September 11, 1928, read, "The first dance at this newly constructed Ballroom will be held by Geo. Monaghan Council K of C." Halloween was a common holiday to open the dance/social season and may have been the date referred to on the banner. Dance event seasons usually did not favor the summer months

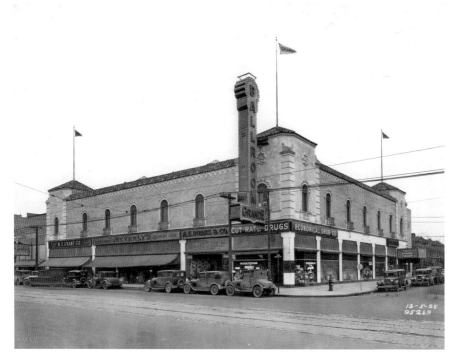

The Grande Ballroom, December 5, 1928. *From the Manning Brothers Historic Photographic Collection.*

because of the heat. Air conditioning was just becoming available, and the ballroom was not so equipped. The dance floor was one of the largest in the Midwest when it was constructed. Featuring a sprung design, it was set on a subfloor, a lattice of wood and cork strips, to allow the dance surface to first give and then return energy to the dancers' feet, like a trampoline. The architect designed the stage to project musical instruments and lecturers without the benefit of electronic amplification. The building was itself a virtual musical instrument.

As did the construction of the Alabama and the Hollywood Theaters, the 1928 construction of the Grande Ballroom ran concurrent with that of the Fisher Theater project.

THE FISHER THEATER, NOVEMBER 1928

Graven and Mayger

Egyptian antiquities fascinated the world after the discovery of the tomb of Tutankhamun in 1922. Native American and Mayan designs also found more appreciation during this period. Graven and Mayger's archives contained bound books filled with illustrations and photographs from junkets to Yucatán Peninsula ruins and temples. What resulted was the original Fisher Theater design, a classic example of Mayan Revival.

The theater itself was not unlike a Mayan temple. Extravagant, if not practical, touches like birds, banana trees and a goldfish pond set the Fisher apart from all the other movie palaces. The exotic birds and Yucatán plants got daily "violet light baths" to maintain their health in their new harsh environment. The stock market crash in October doomed any plans for what was to be a much larger Fisher Building complex. A second thirty-story

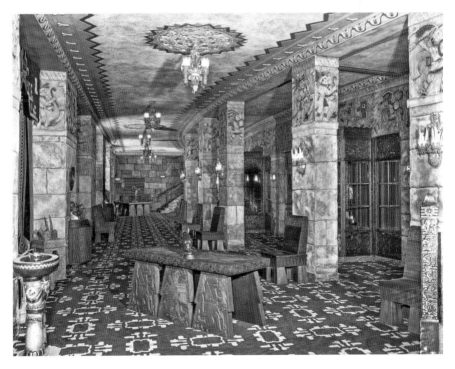

The Fisher Theater's original Mayan lobby interior. Graven and Mayger, architects. *The Edward Rupinski Collection; courtesy Andrew Schneider.*

Fisher Building was planned as the opposing flank to a mammoth central sixty-story tower.

In 1961, the Nederlander family (of Broadway theater fame) hired Graven and Mayger's former employers Rapp and Rapp of Chicago to perform a $4 million "modernization" and redesign of the interior. They destroyed, removed or covered up the spectacular Mayan décor and reduced seating to 2,100 seats. The Detroit Theater Organ Society disassembled and transported the four-manual Mayan Wurlitzer organ and reassembled it at the Senate Theater on Michigan Avenue.

The years 1927 and 1928 proved to be very productive for the new firm of Graven and Mayger, with the pair cranking out many notable properties in very short order. In 1932, Graven tragically drowned in a freak duck hunting accident on Little Rice Lake Minnesota at age forty-two.

Not known is the final disposition of the relationship between Agree and his surviving collaborator Mayger. Agree's firm did presumably profit from the transfer of knowledge, as it did expand further into ballrooms and theaters. All this occurred at a time when the architect's bread and butter apartment projects were becoming scarcer.

THE VANITY BALLROOM, 1929

Charles Agree

Charles Agree was the architect of record for the Vanity Ballroom. However, the Vanity coincidentally featured Mayan Revival décor designed and completed during Graven and Mayger's peak period. Cartouches, tiered Mayan stone designs and stepped arches were very similar to those used in the Fisher Theater. More ornate and radical in its design than the Grande, the Vanity was in many ways its "sister" ballroom. Both had Paul Strasburg dance floor operations featuring external promenades, allowing for traffic flow without patrons having to cross the dance floor. An elaborate external rear fire staircase, as opposed to the simple mandatory fire escape at the Grande, is one such example of the Vanity's fatter budget. Catering to its share of high society, it was close to the mansions of the wealthy in Grosse Pointe and other lakefront communities.

The Vanity opened only sporadically after 1961, including a noted revival and restoration in the 1980s by twins Ronald and Donald Murphy. None of

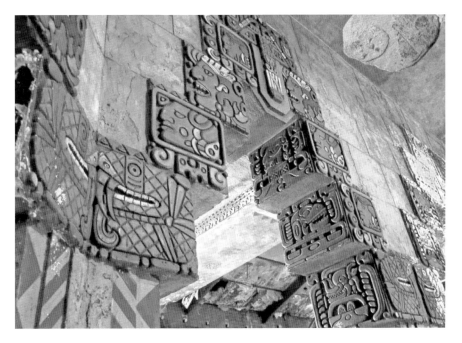

The Vanity Ballroom's Mayan stepped-arch cartouches. *Courtesy David Hichman.*

these efforts was sustainable, and the ballroom was shuttered. The National Register of Historic Places listed the Vanity Ballroom in 1982. Today, the ballroom languishes in decay and neglect at the corner of East Jefferson and Newport Streets.

The Graven and Mayger partnership had lasted only six years, with its most productive period being before the crash of 1929. After Graven's passing, Arthur S. Mayger continued with his own architectural firm in Chicago until his death in 1948 at fifty-eight.

STRADIVARIUS

At the Grande Ballroom Fortieth Anniversary Concert in October 2006, former Grande manager Tom Wright remembered how the Grande's priceless unparalleled acoustics made it the "Stradivarius of Ballrooms." Set amid a dingy retail district that had seen better days, the last thing acts from out of town expected was a venue with such golden, perfect acoustics.

Designing great-sounding halls might still be challenging were it not for one man: engineer Wallace Clement Sabine (1868–1919). In 1894, Sabine set about retrofitting Harvard University's new, but acoustically problematic, Fogg lecture hall. In this age before PA systems, lecturers were unintelligible from its stage. Using stopwatches, portable organ pipes and a team of auditors, twenty-year-old Sabine began calculating how sound decays in different spaces. Ultimately, Sabine determined that "a definitive relationship exists between the quality of the acoustics, the size of the chamber, and the amount of absorption surfaces present." He then developed a formula that could calculate the reverb time of a room if you knew its total volume and area of sound absorption materials. Sabine corrected the Fogg's acoustics with hanging felt banners and other treatments. The first building outside the university to take full advantage of the new sound formulas that Sabine published was Boston's Symphony Hall, which opened in 1900. Symphony Hall was an immediate acoustical success and is today one of the world's most revered concert halls.

Grande architect Charles Agree started his firm in 1919, the same year that Sabine died. Sabine's work had energized the subfield of architectural acoustics. By then, theater architects like Rapp and Rapp were already applying Sabine's formulas in choosing the right materials for a good-sounding space.

Detroit's Orchestra Hall and the Grande both utilized horsehair plaster. Animal hair's primary function was to reinforce the plaster blend. Any acoustic benefit was purely coincidental, though this form of plaster likely had a known, perhaps desirable amount of sound absorption/reflection. Horsehair plaster and lathe were common in the days before mass-produced sheetrock drywall. Sabine's Boston Symphony Hall contains horsehair plaster. Ultimately, a perfect balance between reflective and absorptive surfaces was the goal. In addition, the gingerbread architectural elements—curtains, coves and curves—in the open space of the ballroom (and its movie theater cousins) served to capture and steer sound desirably. Agree had created a sanctuary of sound, a sonic oasis set amid the cacophony of the Ravenswood district. The superior acoustic profile of the Grande was no accident, and its debut heralded a new type of modern space for the enjoyment of music.

EDWARD J. STRATA

Operating out of a lofty office in the Farwell Building at Detroit's Capitol Park, developers Edward "Ed" Strata and Ed Davis built both the Grande and Vanity Ballrooms. Ed Strata was born in New Orleans in 1890, and his primary businesses were insurance and real estate speculation. He and his wife, Nellie, resided for years at 723 Barrington Road in Grosse Pointe Park. His partner, Davis, remains something of a mystery.

Strata and Davis were able to complete the two ballroom projects for the cost of $500,000, including the price of the land. The duo likely built the first ballroom, labeled the "Weitzman Building," to suit the customer. The Grande Ballroom blueprints show a date of May 1928. The second ballroom, the Vanity, opened days after the great stock market crash of 1929. The Depression meant that the Grande and the Vanity were the last two such ballrooms built in Detroit, with the latter's ownership retained by its developers.

A more ornate version of its predecessor, the Vanity catered directly to wealthy Eastside patrons. As was likely the plan, Strata held on to the Vanity for the rest of his life. Rebecca Binno Savage, who in recent years led tours of the Vanity, noted that many patrons recalled Mr. and Mrs. Strata. It was the pair's custom to stand in their fine eveningwear at the top of the stairs to welcome their guests.

The fortunes of the Grande and the Vanity Ballrooms ran in parallel. Recently sold off, the Grande was shuttered in 1964. In February, the *Free Press* interviewed Strata for an article on the fate of Detroit's ballrooms. He and the Vanity were having one final go at bringing back the styles of dance enjoyed decades before. Strata recalled, "I remember in the 30s and early 40s when we'd have 900 couples there on a Sunday night, and maybe 800 on Saturdays, then we'd have on Wednesdays and Thursdays our so-called stag nights when lone boys and lone girls would come in and join the couples."

Harvey Taylor wrote the account on Strata's plans in 1964.

The Ballroom is tentatively scheduled for what is rather optimistically called a "grand opening" Saturday evening. It's designed essentially for retirees and for those of the age who recall dancing to the name bands which once lured them to the Vanity. But anybody with a buck and a quarter is welcome. The dance is part of the program of the Mayor's departmental council on aging. But it is contingent on the advance sale of 250 tickets

specially priced at one dollar. By Tuesday afternoon barely half that had been sold.

The revival dances were discontinued, and Edward J. Strata passed away on June 28, 1965, at age seventy-five and is interred at Forest Lawn Cemetery.

SHALL WE DANCE?

In the daytime, the street-level shops on Grand River were crowded with foot traffic. In this age of ragtime and jazz, the court dances taught by generations of Europeans were giving way to new steps. These modern dances were often at the center of events, both public and private, at the ballroom. They represented a shift in how Americans entertained themselves. Over three decades, only a handful of instructors and managers were responsible for the second-story Grande dance operation.

THE STRASBURG DANCE DYNASTY

Terpsichore

Where now the stately minuet?
Where now the waltz sedate?
Submerged beneath a wave of jazz
They're sadly out of date.

Wild eyed the tango fled apace
To Sunny Argentine,
The hesitation sped away
To pastures new and green.

The gay fox-trot, the grizzly bear,
The twinkle-toe from France—
Where are these steps of yesterday?
Ye worshipers of dance?"

Strasburg Dance Times, *May 1919*

DANCE LEGACY

Paul Strasburg was the socialite who ran the dance operation at the
Grande Ballroom for years. A series of dance academies and private

instruction had generated his family fortune, as noted in the *Detroit News* of September 19, 1914:

> *3 Generations Have Taught Detroiters Arts of Terpsichore*
> *Here is another of Detroit's distinctions, a dancing school, with a record of three generations of one family as instructors. In 1855 Herman Strasburg Sr. founded the Strasburg dancing academy in Detroit, which has been in continuous session for 60 years.*

The *Detroit News* article appeared when Paul Strasburg had come of age and was poised to take over the family business. His father, Herman, had passed away at fifty-six, and Paul came into his inheritance.

The assets of the Strasburg estate included the large Strasburg Dance Academy at 51–53 Sproat Street. In this large, purpose-built building, the family was able to employ squads of instructors who taught scores of students at a time on its seven-thousand-square-foot dance floor. When it opened in September 1909, it was one of the largest rooms in the city. The family's in-house newsletter, called the *Strasburg Dance Times*, included pieces written by the family scion. Strasburg's was purported to be the largest dance school in Michigan.

Ragtime as a dance craze peaked between 1912 and 1914, before the start of World War I. Gradually, all social classes and ethnic groups had accepted the new form and its associated dances. The Strasburgs, however, remained the guardians of the traditional society dance forms. Their "Who's Who of Detroit" entry described the academy enterprise as "strictly a school for dancing and NOT a dance hall." Dance halls were the inexpensive public houses that were favored by Detroit's growing industrial working

Herman A. Strasburg Sr. *Courtesy Orville Cicotte collection.*

WHEN the average Detroiter thinks of learning to dance, his mind turns immediately to one school—the oldest, largest and best school in Michigan—the Strasburg School of Dancing, established 67 years.

All children's and young people's classes start this week. Classes for pupils of all ages, either beginners or advanced dancers, start this week. Write or phone Cadillac 967 for free illustrated booklet of particulars.

STRASBURG SCHOOL

Just Off Woodward on Sproat

Above: Strasburg School ad from November 28, 1921. *From the* Detroit Free Press.

Right: Herman A. Strasburg Jr. (1860–1917). *Who's Who of Detroit; Courtesy of the Burton Historical Collection, Detroit Public Library.*

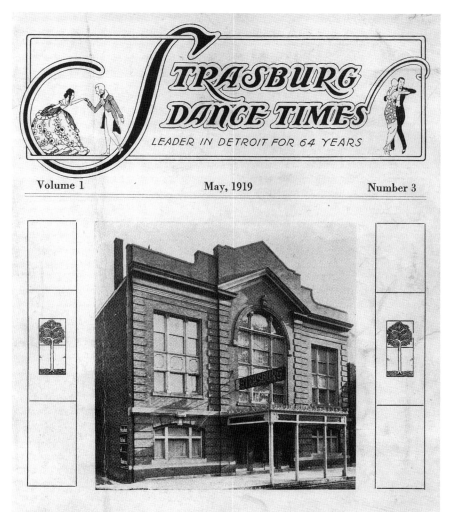

STRASBURG DANCE TIMES

LEADER IN DETROIT FOR 64 YEARS

| Volume 1 | May, 1919 | Number 3 |

THE fourth building erected and used by the Strasburg Dancing Academy in the city of Detroit. This is the only school having its own building and using the entire building exclusively for the teaching of dancing.

Strasburg Dance Times, May 1919. *Author's collection.*

class. The Strasburgs, at least initially, disdained "dance halls," considering them rooms of ill repute and not becoming of their students. Their private dance academies endeavored to produce cultured, refined dancers skilled in the International Standard Style dances, such as Viennese waltz, tango and quickstep. They shunned the common dances like the turkey trot, the black bottom and the grizzly bear—dances one might see at a dance hall,

barn dance or brothel. Paul Strasburg commented on the latest "ugly" modern dance, the "Shimmy Shake," in the April 5, 1919 edition of the *Detroit News*: "The dance is not graceful and the continual starting and jerking is fatiguing. The steps in themselves are not wrong, but the wiggling and squirming is ugly, said Mr. Strasburg. If the dance grows in popularity after the close of the Lenten season, Mr. Strasburg will attack it officially. He is planning to give an exhibition before Dr. James I. Inches, police commissioner, and a committee of ministers and women judges so that they may know the 'horrors' of the 'shimmy' and cooperate in ostracizing it in Detroit."

Throughout the 1920s, Detroit saw its rapid growth matched by the ever-changing fads and styles of modern dance.

Paul Strasburg was a high-profile socialite whose desire for action and speed led him to powerboat racing and modest success in the legendary Detroit Gold Cup Series. Strasburg competed alongside the legendary Gar Wood and drove for other wealthy industrialists like Edsel Ford in these early races on the Detroit River. Strasburg and Wood were also members of the Detroit Flying

Paul Strasburg, aviatior and dance hall owner, June 1930. *From the Walter P. Reuther Library, Archives of Labor and Urban Affairs, Wayne State University.*

Paul Strasburg, June 1930. "Boatman" is written on the back of the photo print. *From the* Detroit Free Press.

club and flew their seaplanes in a number of air tours, including the Great Lakes Air Cruise in the spring of 1930. These expeditions occurred at the same time (1925–31) that Ford Motor was sponsoring their similarly inspired National Air Tours, or Air Reliability Tours.

Strasburg became wealthy during the 1920s teaching Detroit society to dance. He and his wife, Margaret, had one son, Paul Jr. (born in 1917), and by 1929, the family was living comfortably in a large home at 1728 Seminole Street in Indian Village. Paul regularly commuted in his own seaplane to their Lake Huron summer home at Pointe Aux Barques in the thumb area of Michigan.

BALLROOM BLITZ

Both the Grande and Vanity Ballroom spaces were fully leased before opening in 1928 and 1929, respectively. Strasburg's fifteen-year operating lease at the Vanity cemented his expansion into public spaces. The shiny new hardwood floors gave his students a place to practice their steps in a real-world social setting. According to Grande owner Clem Weitzman, Strasburg ran a tight ship—"If you looked drunk, were missing your hat, or appeared just there to get a girl, you were not allowed in."

Strasburg's upbringing stressed proper etiquette and deportment, which was precisely the environment he endeavored to bring to his ballroom operations. He did not stand for "monkey business" and booked the entertainment favoring local orchestras, as they usually charged lower fees. During Strasburg's tenure, the talent that was booked was virtually 100 percent white. This corresponded with his exclusive door policy that supported claims that Strasburg was racist. Clem Weitzman testified, "He didn't like blacks and he didn't like Jews."[6] Weitzman did not care for the dance master, who was a Presbyterian German. Evidently, a lack of interest in dancing was not the only reason Clem Weitzman rarely visited the upstairs operation. Although Clem's father, Harry, certainly entertained at the venue, it was largely a business relationship between the family and Strasburg.

6
JAZZ AGE, DANCE AGE!

*In every living soul, a spirit cries for expression—perhaps this plaintive, wailing
song of Jazz is, after all, the misunderstood utterance of a prayer.*
—The Jazz Singer, *1927*

TALKIES

Henry Ford's five-dollar workday of 1914 had helped trigger a mass
immigration of autoworkers into Detroit. Motion pictures and the dawn
of the Jazz Age were two major elements that drove entertainment demand
in this new mega-city. Soon Detroit saw its own "Temple of Amusement,"
the 5,000-seat Fox Theater, open on September 21, 1928. At the time, the
Detroit Fox was the first theater with built-in sound equipment. President of
20th Century Fox William Fox built the nationwide Fox Theater chain partly
to exploit sound technology, including Movietone's "optical sound track"
patent. By the peak of Detroit's building frenzy in 1929, there were over two
hundred movie theaters in the city of Detroit with a total capacity greater
than 200,000 seats.

HOT JAZZ

In the first couple of decades of the twentieth century, the Detroit Federation of Musicians' Union had in its ranks a very deep pool of talent. Its membership was built from dozens of players who had migrated to town, attracted by the work created by the auto boom. These performers honed their skills in the Motor City's amusement parks and theater pits and in its biergartens and ballrooms. At the Graystone Ballroom, future swing stars like Bix Beiderbecke and Tommy and Jimmy Dorsey paid their dues with Jean Goldkette's Orchestra. Operator Goldkette broke the exclusive whites-only Detroit Ballroom circuit when he offered a Graystone Monday night for African American patrons. Top-selling songs on record often included novelty sides for dance crazes, such as the Charleston and the black bottom. Everybody wanted something to dance to, and the syncopated rhythms served up by the latest dance bands were the "cat's pajamas." An average orchestra payroll for this time might consist of seven to twelve musicians.

Ballrooms sprouted like mushrooms during the first quarter of the twentieth century. Popular music and dancing meant that your visitors stayed at your venue longer. Jefferson Beach, Eastwood Gardens, Edgewater Park, the Walled Lake Casino and the Bob-Lo Pavilion were open all summer with the added attraction of a dance floor. Even the massive Graystone had an outdoor garden for dancing under the stars on a sultry evening.

Dancing was perhaps among the top three of Detroit's diversions in the 1920s. Here is a select list of the most significant venues sorted geographically:

WOODWARD
1914: Arcadia Ballroom, 3527 Woodward
1924: Graystone Ballroom, 4237 Woodward

EASTSIDE
1925: Eastwood (Park) Gardens, Gratiot and 8 Mile
1928: Jefferson Beach Ballroom, 24400 East Jefferson
1929: Vanity Ballroom, 14301 East Jefferson

WESTSIDE
1925: Walled Lake Casino
1927: Edgewater Park Pavilion, 7 Mile and Berg Roads
1928: Grande Ballroom, 8952 Grand River

ONTARIO, CANADA
1914: Bob-Lo Pavilion

THE PURPLE GANG

The Purple Gang, made up of mostly Jewish members, was one of the Midwest's most notorious collections of criminals. They dominated Detroit organized crime in the 1920s and early '30s, controlling nearly all of the city's liquor, gambling and drug trade. The gang operated a number of speakeasies itself and extorted protection money from other such operations. Spending lavishly, its members often mixed with members of Detroit society at golf clubs, yacht clubs and ballrooms. Weitzman's Grande was likely also among their hangouts. Paul R Kavieff quoted musician Milton "Mezz" Mezzrow in "The Purple Gang-Organized Crime in Detroit": "The Purple

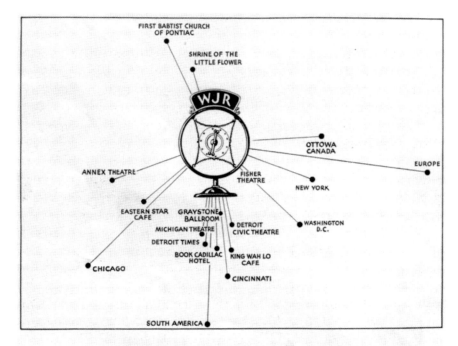

WJR Broadcasts from Many Outside Points

WJR radio annual program's remote-broadcast map, 1929. *Courtesy the estate of Carl and Maggie Ekstrom.*

gang was a hard lot of guys, so tough they made Capone's playmates look like a kindergarten class....Detroit's snooty set used to feel it was really living to talk to them hoodlums without getting their ounce brains blown out."

The profit potential of illegal alcohol spawned a number of gangs that were trafficking, hijacking and diluting booze for consumption. Some of these gangs aligned themselves with various restaurateurs, theater operators and dance hall owners.

Radio station WJR had advanced from its first broadcast in 1922 (as WCX) to incorporate radio technology that made remote broadcasts possible at Detroit's many theaters and ballrooms. One can imagine WJR broadcasting live from the Graystone Ballroom as members of the Purple Gang, flamboyantly dressed, trawled the dance floor for women.

Ballroom construction stopped in Detroit after the stock market crash in October 1929. Although the public still managed to afford admission to ballrooms and theaters, musicians and orchestras were still struggling.

FATAL FOXTROT

On Wednesday night, April 20, 1932, twenty-one-year-old department store clerk Gregory Clancy had gone to the Grande Ballroom seeking his estranged fiancée, twenty-year-old Geneva Ulman. The couple had argued three weeks prior, and the girl had since refused to speak to him. Gregory had just learned that the girl's parents objected on religious grounds to their marrying, and he had recently purchased an automatic pistol "for no special reason."

Wednesdays and Thursdays at the Grande were typically stag nights, where unattached singles could join the couples. Clancy, seeking reconciliation and upset that Geneva had gone dancing without him, tracked her down to the venue. When he entered the ballroom with his pistol concealed, his frustration reached a murderous level, and Clancy shot Geneva nine times on the crowded dance floor. "I had no intention of using it when I started out to hunt for her," he later confessed. The *Detroit Free Press* further quoted the killer, who did not recall the gunshots, "I saw her in the dance hall, and then everything went blank. The next thing I remember was how white her face was as she lay there on the floor." He was immediately captured by the other dancers and arrested and was relating a full confession to Detroit homicide detectives by that Thursday morning. "I would give anything to have her living again," he sobbed.

Not permitted to attend Geneva's funeral, Clancy ultimately entered a plea of guilty to second-degree murder. On May 10, Judge Arthur E. Gordon sentenced him to serve ten to thirty years in Jackson State Penitentiary.

BALLROOM SEGUE

Talking pictures, the home entertainment phenomenon of radio and the stock market crash all did their parts to drive Strasburg to seek alternate opportunities in outside venues by 1935. Speaking to the *Free Press* in 1957, Strasburg clarified why he had sold off the Sproat Street academy and his interest in the ballrooms:

> *No new inspirational step had come along, as the foxtrot had done, to interest people. The "rumpus rooms" are taking some of the kids, but most are not learning the social graces that only learning to dance correctly can give them. How to ask a girl to dance. How to seat her properly after the dance. How to make an introduction. How to walk. How to sit gracefully.*

That year, Paul began conducting dance classes in zero-overhead private settings, such as the Country Club of Detroit and the Detroit Yacht Club. Preferring instruction to management, his focus shifted to private assemblies; however, he did continue to instruct at both ballrooms through the 1950s.

ENCHANTMENT UNDER THE STARS

Many area Catholic parishes did not have large enough spaces to accommodate big dances or proms. The Detroit Archdiocese's Catholic Youth Organization, or CYO, regularly held dances and mixers at the Grande. So, too, did the Catholic Inter-Parish Association that included St. Alphonsus, St. Leo's, St. Theresa's, St. Brigid's and a half dozen other Westside parishes. The Grande became a very special place to hold your prom, wedding or bar mitzvah, a true palace that created lasting memories for hundreds of young people.

WDET's Jerrin Zumberg reported, "Minnie Adelson was in her early 20s when she sneaked out on the weekends and took the Grand River

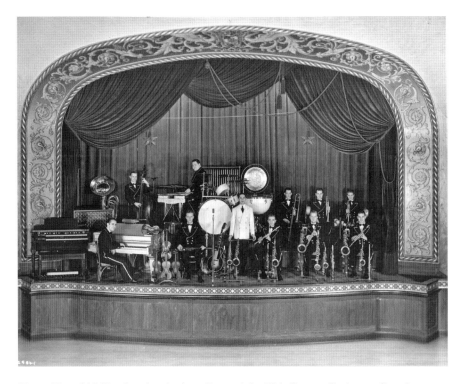

Henry (Kowalski) Van Steeden, keyboardist, and the Walt Shuster Orchestra Grande Ballroom, 1937. *Courtesy Cat Manturuk.*

streetcar up to the Grande with the hopes of 'finding a fella.' 'We could dance outdoors under the stars. It was so beautiful under the stars on a warm night.'"

Minnie may very have well heard the Walt Shuster Orchestra and the bright tones of Henry (Kowalski) Van Steeden's piano drifting up the stairs and out into the indigo Michigan night sky. Henry was a lifelong pianist and organist who regularly played the ballrooms. The image above sat atop his piano at home for decades, proof of his accomplishment and a more refined time in Detroit.

In 1935, Benny Goodman ushered in the swing era with a legendary gig at Los Angeles's Palomar Ballroom. All of Detroit's ballrooms competed to book such popular swing recording bands. The swing craze trickled down to the local tier orchestras as well and likely sustained ballroom business for the duration of the Depression. However, the Great War presented its own set of challenges to large bands and dance entertainment.

7
THE WAR

CHANGES AND CHALLENGES

After the United States joined World War II in 1941, the Grande's role became even more important. Morale was key, and workers holding down the homefront could take advantage of special swing shift dances held at odd hours to accommodate them. Rationing was in place, and booking entertainment for the home ranks was costly. Unless underwritten by entities like the USO or other charitable or defense-related organizations, the majority of big bands found it difficult to travel. In addition, enlistment in the armed forces had decimated the ranks of both local and touring orchestras.

Competition from outside pavilions (or sheds) and the lack of air conditioning caused the Grande to shut down in the summer. Dancers could go to Walled Lake, Bob-Lo, Jefferson Beach, Eastwood and Westwood Gardens to dance out-of-doors on a hot summer night.

By the 1940s, scores of distributor/operators were making millions by the nickel leasing and managing jukeboxes in public places. During the war, there might be an entertainment tax on your ballroom ticket, but it still cost only a nickel to dance to some "sides" at the local soda fountain. Machines were increasingly becoming yet another force competing directly for the public's entertainment dollar.

In July 1942, the music-publishing juggernaut ASCAP (American Society of Composers, Authors and Publishers) went on strike, directly affecting

Grande Bandman

Lowry Clark, popular Detroit orchestra leader, opens the dance season at Ballroom Grande Friday evening. There will be dancing at the Grande every Friday, Saturday and Sunday.

Lowry Clark, orchestra leader, September 11, 1946. *From the* Detroit Free Press.

recording and radio transmission of its members' material. This also meant a drastically increased rate for ballroom operators, who were responsible for performance fees of any orchestras performing ASCAP material in their venues. At the Grande, manager Paul Strasburg refused to pay up. Consequently, orchestras had to "cut their books," meaning they had to remove all ASCAP tunes from their repertoire.

Another change in music culture that directly affected ballroom operations was the rise of the pop singer. In the 1930s and early '40s, big bands usually had a singing group or single singer who was occasionally featured during the program. Now it was the singer in front with the band as accompaniment. By the time the war ended, bands had shrunk, and the number of vocal arrangements and vocalists increased. A typical local example was the Ralph Bowen Orchestra. Their leader, Ralph Bowen, explained representative configurations: "At the Grande we used ten men starting out. At the Graystone we used fifteen[, including] five brass, five saxophones plus piano and a vocalist."[7]

The public's taste for the pop singer was paving the road for the teen idol of the 1950s. The orchestra, sadly, moved further into the shadows of the ballroom.

As with the advent of swing, musical styles continued to evolve. In New York City (and Detroit, too), artists like Charlie Parker and Dizzy Gillespie were purveying a new modern form of jazz called bebop. As these styles were more conducive to listening than to dancing, venue operators catering to this crowd filled the old dance floors with tables and chairs.

In Detroit, the abandonment of the streetcar lines was a twenty-year process that began in 1937. Grand River was the first major streetcar line to switch to the smelly diesel coaches on May 5, 1947. After the war, Detroiters were losing their streetcars but were becoming more mobile in a different way. Traffic on Grand River became very dense, and parking became problematic for theatergoers and ballroom dancers alike.

The decade of the 1940s proved just as challenging for the Grande Ballroom as the 1930s. Entertainment became more expensive and consequently more difficult to exhibit. Musical styles evolved and multiplied. Transportation and the demographics of Metro Detroiters shifted to the suburbs. In addition, in 1942 the luminous owner of the Grande Ballroom, Harry Weitzman, passed away.

THE 1950s

The decade of the 1950s was one of drastic change for the Grande Ballroom. As Detroit's population continued to shrink, the old hall witnessed major demographic shifts and the loss of one of its major proponents.

SUNSET ON GRAND RIVER

In the days of Detroit's streetcars, operators had constructed steel and concrete safety zones from which riders boarded the cars from what would be today's left turn lanes. On the night of November 4, 1950, Grande Ballroom operator Paul Strasburg was involved in a severe auto accident involving a "safety zone." The wreck was big news, and it made the first page of the Sunday edition of the *Detroit Free Press* the next day. A photo showed the crumpled car and Strasburg, with his back on the pavement and his feet still on the front seat. "Crashing into the safety zone on East Jefferson, seriously injured Paul Strasburg 58, of 1100 Parker, owner of the Grande Ballroom. Strasburg told police a cab forced him into the posts. The accident occurred in front of Jennings Memorial Hospital."

Bandleader Ralph Bowen recalled seeing this image. "I do believe he was really banged up, they had a picture of him in the paper lying in his car before they took him to the hospital. Yeah it knocked him out of the thing and I think that was probably the cause that took him out of the business."

Paul Strasburg, dance master, without his wheelchair, September 1957. *From the* Detroit Free Press.

Despite the proximity of the wreck to Jennings Memorial, Detroit's dance master sustained injuries that crippled his ability to walk or dance. Though he was no longer ambulatory, Paul soon resumed his dance classes at the country club of Detroit. Utilizing female assistants for the legwork, his expertise was still in demand by Detroit society, and he continued to teach into the next decade.

Strasburg apparently also continued to hold limited classes and run the dance business at the Grande Ballroom until 1954. That year, *Billboard*, the weekly entertainment paper, stated, "Paul Strasburg has disposed of his interest due to serious injuries from an auto accident." A team called A.C. Management was now announcing another fall "reopening" of the Grande Ballroom. Listed in the 1954 city directory at 8952 Grand River was a Coronella Dance School with principals Albert Alberts and Joseph T. Coronella.

In 1961, Laurena Pringle of the *Free Press* found Paul Strasburg, age seventy, still teaching young children at the country club. The former fleet-footed dancer, athlete and speed demon continued to instruct seated on a chair in the center of the dance floor. With his modest Eastside home filled with trophies from air and hydroplane championships, he still promoted a "life of action." After looping one of his airplanes under the Ambassador Bridge, Strasburg once had to answer to a judge. When asked why he had done it, he testified, "A fellow might as well be dead as sit forever in a rocking chair."

THE RALPH BOWEN ORCHESTRA

University of Detroit High School graduate and saxophonist Ralph Bowen played professionally up until the start of the war. Once discharged from the air corps in 1945, he quickly formed a Detroit orchestra of his own. Ralph recalled the required level of decorum on Detroit dance floors, "[At the Grande] you had to be dressed, you had to have a coat, shirt and tie if you didn't have a tie they lent you one. It was the same in all the ballrooms; you couldn't go in there looking like a bum."[8]

Bowen and his orchestra performed and toured quite frequently. By the mid-1950s, Bowen quit the road when one day he arrived home and his young preschool-age daughter did not recognize him. Through the early '60s, the Bowen orchestra continued to appear on the Detroit ballroom circuit,

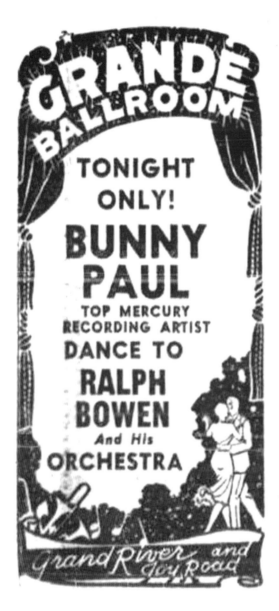

Ralph Bowen and Bunny Paul Grande Ballroom ad from September 26, 1954. *From the* Detroit Free Press.

often backing singing stars and vocal groups. One such singer was Bunny Paul (born in 1924), who started her career in 1946 with "Detroit's Lawrence Welk," Don Pablo, and his orchestra. Pablo often featured Paul's stylings at the Grande. Billed as a chanteuse and recording artist, Bunny appeared at the ballroom throughout the 1950s. She was one of the first white artists signed to Motown records in 1963 but experienced limited success.

BALLROOM TRAGEDY

An outstanding example of the union musicians Detroit had on call was Bruno Jaworski, who at age thirty-five was a hardworking trombonist with a large family to support. He did so by playing in several dance orchestras in Detroit's ballrooms, country clubs and VFW halls. Bruno regularly played the Grande and was a contemporary of bandleader Ralph Bowen. Jaworski was a well-liked performer in the radio orchestras, too, backing personalities on stations WXYZ and WJR. A "first call" member of the

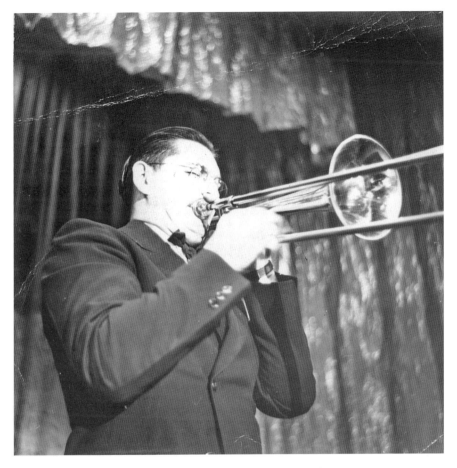

Bruno Jaworski's "Glen Miller" promotional photo. *Courtesy Mary Ann Jaworski Borgon.*

Detroit Federation of Musicians, Local 5, he was booked to play a dance with the Russ Weaver Band at Edgewater Amusement Park's pavilion on Sunday, October 3, 1954. That night, a line of severe Indian summer thunderstorms blew through the park. Allegedly, a lightning strike ripped through the air-conditioning system, sparking a fire in the hall's upper ceiling. Patrons were slow to evacuate outside into the pouring rain. As fire consumed the ceiling, Jaworski ran back in to save his instrument, his income. The *Detroit News* reported his last words were "I can't lose that horn." The false ceiling collapsed, killing Bruno and one other man. Russ Weaver and three other band members narrowly escaped. A few weeks later, an unprecedented twenty-one Detroit-area orchestras came together to play a charity dance to benefit his widow and six children. Some 2,500 people

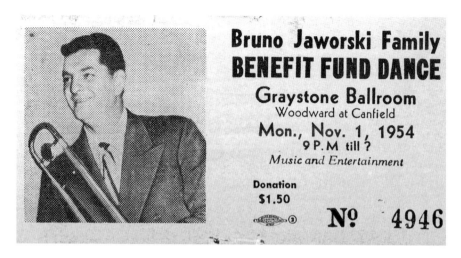

Bruno Jaworski Benefit Fund dance ticket, 1954. *Courtesy Mary Ann Jaworski Borgon.*

attended, a testament to his popularity. Throughout his career, Jaworski had toured with the Tommy Dorsey and Xavier Cugat orchestras, but eventually, he only accepted local work to stay close to his kids. Many of Detroit's music community attended his funeral in tribute on October 7, 1954.

MR. AND MRS. JOHN HAYES

After A.C. Management folded in 1955, the operation of the ballroom transferred to a Mr. and Mrs. John Hayes of Redford. The listed telephone number for the Grande through at least 1962 was TY4-1010 or, "if no answer: KE3-8465," the Hayes residence.

In 1957, the family appeared in a *Detroit News* article: "Dance Hall Revival—Ballroom Boasts Grace and Decorum." In it, John Finlayson described the Hayeses' romantic yet conservative approach to offering a public dance venue. "We are seeking to make the Ballroom the type of place where young people may meet and enjoy dancing in wholesome surroundings," chimed Mrs. Hayes. The couple, along with their teenage son and daughter, hosted dancers in an alcohol-free, squeaky-clean environment. "We do not serve beer or liquor, nor do we allow persons who have been drinking on the premises, this is not a pickup place. The fox trot, tango, waltz and bolero and other Latin dances are popular, but occasionally swing numbers and even the Charleston is served. The

THE GRANDE

8952 GRAND RIVER NEAR JOY

TY. 4-1010 — KE. 3-8465

Detroit's Only Catholic Managed Ballroom

Hayes family Grande Ballroom business card, circa 1957. *Courtesy David Hichman.*

current favorite of our dancers is the Cha Cha Cha, and many of our patrons are trying to master its intricacies."

These offerings seemingly were counterproductive in light of the period's demand for rock 'n' roll. Yet the operation remained in business for some years despite the nostalgic tastes of its operators.

DIXIELAND AND THE MAMBO

In 1958, the United States was still experiencing a Dixieland revival, which was the complete opposite of the bebop and modern jazz that was going on. In *Jazz on Record: The First Sixty Years*, author Scott Yanow observed: "Dixieland was at the height of his popularity in the early 1950s. The music, which had been largely underground in the 1930s, had begun its comeback in the early 1940s [and] had really gained steam during the following decade."

Also at this time, Latin rhythms like the mambo, merengue and cha-cha had filtered out into the U.S. provinces via New York and Miami. Popular singers of the day latched on to these genres and released homogenized Latin discs like Rosemary Clooney's "Mambo Italiano" from 1954. At the Grande, the popularity of these forms of music allowed the doors to stay open. Detroit had a sizable pool of Latin musicians and combos that were

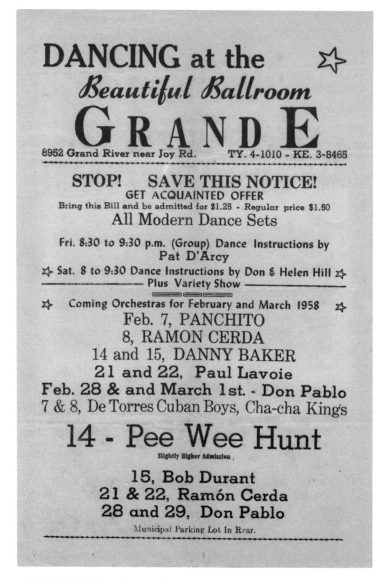

A 1958 Pee Wee Hunt Grande Ballroom handbill. *Author's collection.*

affordable to book. Likewise, Dixieland bands like Pee Wee Hunt's were inexpensive enough to keep costs down. Trombonist Hunt was a former member of Jean Goldkette's Graystone Ballroom–based orchestra.

THE PLANETS ALIGN

In August 1961, the *Detroit News* reported that the Hayes family were still operating the Grande Ballroom. "Of the dozen or so Ballrooms that once flourished in and around the city, only the Grande still operates with any recognition of what Ballroom dancing used to be....The Grande Ballroom 8952 Grand River, has been operated by Mr. and Mrs. John Hayes since 1955. The Hayes [*sic*], hoping for a revival of the art, draw about 700 dancers on Saturday night."

At the start of the decade, only a few ballrooms remained standing in Metro Detroit. Too many entertainment choices and the progression of modern music had begun to spell the end for ballroom dance. The Hayes family did not hold out much longer. With city population decreasing and retail tenants difficult to find, the Weitzman family let the property go, choosing to relinquish it to the insurance company that held the note. Not interested in holding the property, the company had it listed it for sale by the spring of 1964. As the Grande Ballroom collected dust, two personalities arrived who would create a bright future for the venue.

The Grande Ballroom, shuttered, 1961. *From the* Detroit Free Press.

GABRIEL GLANTZ

YOUTH

Born on January 9, 1920, in Hungary to parents Mary and Samuel, Gabriel Glantz immigrated to the United States as an infant. As a pupil, he studied piano with noted Detroit classical pianist and instructor Mischa Kottler and developed a love for music. Gabriel attended Wayne State University Law School and served as an army supply sergeant during World War II. By the late 1950s, Glantz was speculating in real estate that had been theaters or dance halls, as he was passionate about the arts and entertainment. According to his daughter Arlene Glantz Blum, the first of these properties Gabe owned was a beatnik club at 8231 Woodward dubbed the Tantrum circa 1959. While booking entertainment events to pay the mortgage, Glantz learned at the Tantrum that novelty equals profit. Some of his first acts were cutting-edge entertainment in the form of female impersonators. Also, in 1959, the Hungry Eye at 4615 Vernor was another Glantz property that packed in more beatnik kids digging the music and the often-suggestive Beat poetry of the late '50s. These early offerings of diverse forms of entertainment were forerunners of a vibrant Detroit music scene in the coming decade.

In addition to his law practice and string of clubs, Glantz saw an opportunity to produce franchise exhibition shows at nearby Cobo Hall in 1963. Gabe rented booths to companies looking to sell franchises from the exhibit floor. Arlene Glantz Blum remembers taking phone calls at her father's

Penobscot office from dozens of interested exhibitors. These annual "Franchise Expos" drew as many as twenty-five thousand would-be entrepreneurs at a dollar a head and ran profitably through the end of the decade.

THE VILLAGE

Howard Crane, of Fox Theater fame, designed the Garden Theater, a nine-hundred-seat auditorium at 3929 Woodward Avenue that was one of the first built outside Detroit's downtown core. Completed in 1909, the Garden aptly featured décor simulating an outdoor green space. The retail portion of the building helped it remain financially viable through the world wars, but the venue had ceased showing films by 1949. In 1960, Benny and Ethel Resh operated their Club 509 at the address before soon selling out to the Glantz family.

Around 1961–62, Gabe, along with his brother, Leo, began booking R&B vocal groups and other musical acts into their new dry teen club at 3929 Woodward, now called the Village. The Tokens' 1961 number-one single, "The Lion Sleeps Tonight (Wimoweh)," contains the line, "Near the village, the peaceful village, the lion sleeps tonight." The Glantz brothers capitalized on the record's success and its coincidental mention of their club in the lyrics. As a publicity stunt, they hired an actual lion and its tamer to prowl the stage while Gabe played the Tokens' hit over and over. Recording artists such as Nathaniel Mayer, Nolan Strong, Gino Washington and David Ruffin all appeared at the venue. According to guitarist Jimmy McCarty, "A majority of the acts were black R&B and Doo Wop performers, it was really an R&B club." It was in early 1964 that McCarty and drummer Johnny "Bee" Badanjek first worked with singer Billy Levise at the Village. Billy often sang with an R&B group called the Peps and had already cut some records of his own. Thereafter known as Billy Lee and the Rivieras, the group polished a high-energy rock 'n' roll set at the Village that secured them a national recording contract and a new name, Mitch Ryder and the Detroit Wheels. Glantz continued to acquire additional properties but still operated or leased 3929 Woodward under different names throughout the 1960s. Two examples of these were the alcohol-free Et Cetera (1966), which again showcased folk, R&B and blues acts, and the See (1967), briefly operated by the Trans-Love Energies crew from the Grande Ballroom.

THE GRANDE BALLROOM

One day in early 1964, Glantz and his wife, Sylvia, were out for a drive, scouting properties as they often did. Turning up Grand River, they stumbled on an old, large ballroom that was up for sale. Glantz immediately got out of the car and stared up at the façade. Sylvia shouted, "Gabe, what do you need another property for?" Glantz immediately saw the potential, and with some help from his father-in-law, Irv Kliman, he submitted a successful offer for the Grande Ballroom.

Irv Kliman (left) and Gabriel Glantz, 1968. *Courtesy Arlene Glantz Blum.*

Gabe Glantz at his newly acquired Walled Lake Amusement Park property, 1969. *From the Walter P. Reuther Library, Archives of Labor and Urban Affairs, Wayne State University.*

The Grande's next incarnation was as a roller rink catering to the neighborhood teenagers. Its operation caused much damage to the interior—not to mention the paint job of obnoxiously loud colors—and dance floor. The owners had scrapped the rink by 1965. Thereafter, first-floor retailers in the building were using the second floor to warehouse items such as mattresses and paint. In 1966, Glantz made a connection with another entrepreneur of like mind, a teacher and disc jockey from Dearborn, Michigan, named Russ Gibb.

10
RUSSELL JAMES GIBB

THE FAMILY GIBB

James Hutton Gibb was born into a shepherd's family in Dundee, Scotland, in 1902. Whereas all of his eight siblings entered the medical field as doctors and nurses, young James ultimately became a machinist and millwright. Jessie Noble Boath was born in the small whaling and fishing town of Arbroath, Scotland, sixteen miles east-northeast of Dundee.

Since the initial announcement of Ford's five-dollar-a-day wage in 1913, workers had been migrating to Michigan from all over the world in search of employment. In 1923, James Gibb, age twenty-one, set sail for the United States and the promise of work. Gibb did indeed find employment in Detroit's burgeoning auto industry, setting himself up in a series of dwellings close to the auto factories. In 1927, Jessie Noble Boath arrived in Detroit, and the couple married in 1928. Rent was thirty-five dollars a month, and the couple shared the home with two fellow factory workers, including Jessie's newly arrived elder brother William. Jessie found work as a domestic in the many domiciles that sprouted up around Ford's factory. James worked at Ford's as a millwright. Not far from the towering Rouge plant smoke stacks, James and Jessie Gibb welcomed their first and only child, Russell James Gibb, on June 15, 1931.

BOYHOOD

The first family move Russ recalls is one to an upper flat on Willette Street on Detroit's far Westside. This move was apparently concurrent with Russ beginning his grammar school education at the Hanneman School at 6420 McGraw Street. Like many kids of the Depression, Russ discovered radio. He spent many hours listening to classic radio serials of the day when the family got their own radio set. In Detroit, WXYZ ran radio dramas like *The Lone Ranger* and later *The Green Hornet*. Russ regularly tuned in to hear Jack Surrell spin sides like Charles Brown's "Drifting Blues" or Nellie Lutcher's "Fine Brown Frame." Gibb and his pals also dug the honking, sometimes risqué blues and R&B they found on stations like WCHB, broadcasting from Inkster.

Detroit saw hundreds of new movie theaters built during the 1920s and '30s, and Dearborn certainly had its share. As exciting as radio was for young Russ, nothing was cooler than catching a picture show in the air-conditioned comfort of the Circle, the Carmen or the Dearborn Theaters. A movie at the Dearborn Theater, however, was a special treat and required a drive out U.S. 12 to Dearborn's developing west end.

The year before the Pearl Harbor attack, Russ had experienced firsthand the coming darkness in Europe. Russ has memories of summer vacation in Scotland digging backyard shelters and filling sandbags as air-raid balloons and RAF aircraft filled the air. By August 1940, bombs began falling, but by then, the family had already escaped the island, returning to their adopted country in a military-escorted transatlantic convoy.

By 1942, when Russ was eleven, the Gibbs had saved enough money to purchase a modest brick bungalow at 7729 Kentucky Street in Dearborn, which was in the "Fifty States," a new subdivision on Dearborn's far eastern border. The war was in full swing, and Ford Motor Company was headlong into war production. Russ's father could take the Wyoming streetcar behind their house directly to work at the Rouge factory not ten minutes away. Russ attended nearby Macdonald School from third grade through junior high and the duration of the war.

Russ then attended Fordson High as part of the first freshman class of the nuclear age. "Most of us were children of immigrants… overwhelmingly," and "no one gave a damn about your last name," Russ recalled. Russ and another drama student volunteered to be "lighters" for performances in Fordson's ornate theater. Russ was enthralled with this because, for the first time, it afforded him an opportunity to peek

behind the scenes. The pair scaled the stage proscenium and hid in the ventilation crawlspace beneath the seats, "but of course we fucked off," explained Russ, and drama coach Lila Zang sternly reprimanded the pair. Nevertheless, it was good exposure for the future impresario, as Zang also introduced him and his class to Shakespeare and other classics, reading aloud as she walked the aisles of her classroom. Russ's uncle had an old Zenith radio with one special feature: long before affordable tape recorders, it had cardboard discs that allowed one to record a few minutes of audio. "I remember doing some of my first…pretending I was on the radio with those." While Russ was visualizing a future career, his good buddy Jim Dunbar, who was a bit older, broke into radio first while still in college at MSU. Jim soon got a gig in Flint and then at WXYZ in Detroit. Another Fordson friend, Roger Craig, attended Wayne State before launching his law and political career.

As with all teenagers, Russ sought to expand his social profile and meet girls. Russ formulated a master plan to become more popular at school. Hosting parties, Russ often orchestrated a skit or assembled a singalong. Former state senator Roger Craig recalled his pal Russ as the "Toastmaster." "He would, every week or so, have a party down in the basement at his place. What he would do is, as opposed to the usual stuff that high school kids do…his were always talent shows.…If he found five, six people who could do something, they would do it. He would kind of be the toastmaster and handle it, the activity. He did that until he went away to Michigan State."

Fordson was where Russ built some lifelong friendships. Future radio host Jim Dunbar introduced Russ to the latest jazz discs. Jim recalled, "My brother and I were both a bit more sophisticated in terms of our appreciation of music." Younger brother Bill Dunbar was close to Russ and in the same grade. "Back then you could get your license at twelve," Russ recalled. Progressive hepcats with forged proof of identification, Russ and the Dunbar boys drove down to Detroit's Hastings Street neighborhood to visit the "Black and Tans." Black and Tans like the Flame Show Bar and the Brown Bomber Chicken Shack were nightclubs that featured predominantly African American acts performing for an integrated audience. It was thrilling for Russ and his bunch to check out the local musicians and chase skirts. Russ and his pals even ventured down to the Paradise Theater (now Orchestra Hall), where acts like Cab Calloway and Duke Ellington were often booked. The first time the Dunbars and Russ saw Count Basie was at the Graystone Ballroom, also on Woodward.

Another component of the master popularity plan came about rather inadvertently when Russ traded his portable Royal typewriter (a relatively high-ticket item for the day) for a motorcycle. On his first time out, Russ lost control of the bike and plowed through the wooden lattice of a local billboard. Once Russ got the hang of riding, he soon connected with a number of other high school motorcyclists. A local biker club denied them membership, so the kids created their own club, the Highwaymen, with Russ becoming the first president.

After graduating from Fordson, Russ enrolled in Michigan State University (MSU) in 1949. He soon set off for what the kids back in Dearborn called the "Cow College" or "Moo U." Between MSU, summer semesters and additional work at the new Dearborn campus of the University of Michigan, Russ studied educational radio and television administration and earned degrees in English and American history.

THE DISC JOCKEY–TEACHER

Motivated by his high school friend Jimmy Dunbar's radio success, Russ started to work part time in broadcasting. Russ told Keener13.com, "I was a floor director for WWJ-TV and heard about WBRB. The station was licensed to Mt. Clemens and had studios in the old Colonial Hotel."

Russ got his first on-air job from Bob Maxwell, who owned the station. The Old Colonial Hotel and Bath House was a nineteenth-century stone building originally built as a sanitarium. At the Colonial, there was not much separation between the baths and WBRB's broadcast facilities. Russ recalled, "Old Jewish men from the baths would wander in half naked with or without their towels."

Russ's first teaching job at Howell High paid him a salary of $2,200 per year. Although teaching was a solid way of making a living, Russ still aspired to a career in broadcasting. He had heard from fellow radio hosts about how they made extra income hosting teen sock hops. Aspiring to do likewise, Russ realized he had a connection with a teen audience already. There was just one problem. Howell was a stronghold of the John Birch Society, an extreme right-wing anti-communist group. The Birchers did not approve of dancing to "beat music," least of all at school functions. Russ's first proposal to host a similar type of rock 'n' roll dance at Howell High generated stern conservative opposition.

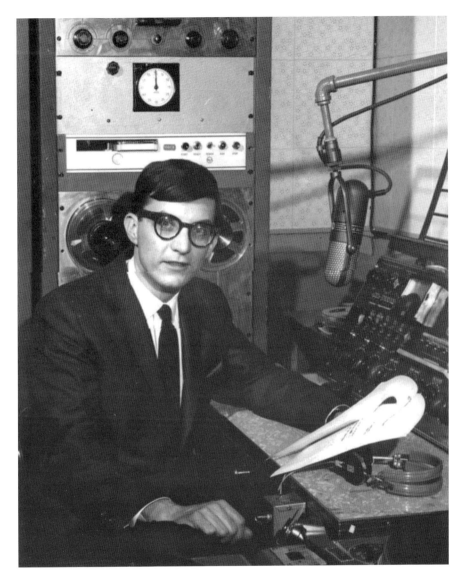

Russ Gibb at WBRB, Mount Clemens, circa 1961. *Courtesy Russ Gibb.*

Seizing an opportunity, Russ rented the local Elks club for twenty-five dollars, stocked it with soda pop and potato chips and hired radio host Gary Stevens to spin records for the teenagers. After paying the host fifty dollars and covering all expenses, Russ went home with more money than he made in a couple of weeks teaching, giving him an idea. His desire for a more relaxed entertainment climate in which to moonlight

CAP VFW - CADET DRILL TEAM

PRESENTS

WKMH "Men of Music" DANCE

FEATURING

Dee Jays, Ray Otis ■ Russ Gibb
■ In Person Recording Stars ■

Saturday, APRIL 7, 1962 - 8 to 12 o'clock

ROMULUS PROGRESSIVE HALL, Romulus Mich.

DONATION $1.00

WKMH Civil Air Patrol dance at Romulus Progressive Hall, 1962. *Courtesy Tom Lubinski.*

and a better teaching salary led him to a relatively progressive school system in Wayne County.

Romulus, on the western edges of Detroit's new Metropolitan airport, was a small town in the path of ever-expanding suburban sprawl. In the late 1950s, Romulus High School was swamped in the first wave of the postwar baby boom. There Russ first observed some kids that he referred to as the "opinion makers." They were kids who dressed a little differently, listened to different music and were not interested in following rules. Russ now had a unique perspective on a demographic that became his primary audience.

Exploiting his media connections, Gibb continued to stage record hops and dances throughout Wayne County. Deejays like WKMH's Ray Otis and later WKNR's Jerry Goodwin came on board and ran shows at rentals like the Romulus Progressive Hall. They brought all the records and a record player and sometimes a public address system. Russ also posted and distributed handbills and fliers at places kids frequented, like burger joints. Record companies were always eager to send out their talent at no charge to do a "record date." At record dates, artists lip-synced their latest record in front of their target audience, just like on *American Bandstand*. Record dates were great in that artists did not need to travel with a band or any equipment, keeping promotional costs low. Russ also was learning about how to give away the salty popcorn that made it easy to push the requisite

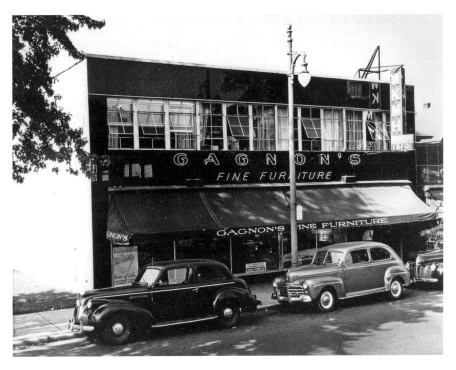

WKMH 1310 AM above Gagnon's Department Store, 22266 Michigan Avenue, Dearborn, 1946. *Dearborn Historical Museum.*

icy-cold Coca-Colas. Russ even famously rebranded one VFW hall the "Pink Pussycat Club."

WKMH radio 1310 AM launched in 1946 with a transmitter broadcasting at a whopping two thousand watts. The original on-air studios were located on the second floor of 22266 Michigan Avenue in Dearborn.

WKMH/WKNR program director "Black Frank" Maruca hired Russ for his qualifications from working weekends at WWJ-TV and at WBRB. It turned out that Maruca had also just been brought on board as part of a corporate initiative.

WKMH was planning a major revamp that included a new call sign and a new "up-to-the-minute pop music and news format." Created to compete in the local Top-40 wars, the new station was to feature a tight thirty-one-song, twenty-four-hour playlist with fast-paced announcements from the on-air talent. The new WKNR AM Dearborn went live on Halloween 1963 and was an instant success, leading the ratings.

Russ originally did production work for Black Frank and "fill ins," which led to a regular weekend daytime slot. Russ negotiated to use his salary to

pay for WKNR spots for his music promotions. By 1966, he was making $3,000 a year from this nine-hour shift and eventually applied all of that and then some toward spots for his events. His nationally syndicated call-in talk show *Night Call*, sponsored by the Methodists, did not broadcast in Detroit and ran from 9:00 p.m. to 2:00 a.m.

CIVIL AIR PATROL

Russ joined the air force reserve in about 1962. Rather than spend a weekend a month camping or other such nonsense, Gibb found that he could manage programs for the Civil Air Patrol (CAP) to fulfill his obligation. The Civil Air Patrol is the official civilian auxiliary of the U.S. Air Force, and similar to the ROTC, it offers training and discipline to young men age twelve to twenty-one.

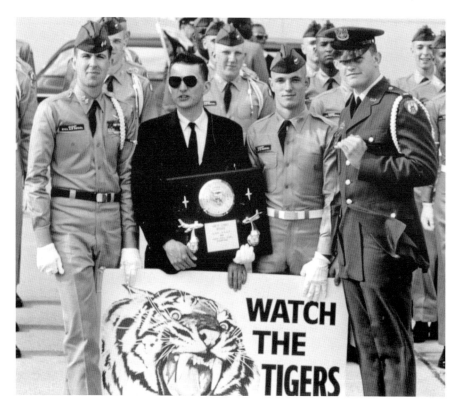

Russ Gibb (second from left) at the Civil Air Patrol regional drill competition, Grosse Isle Airfield, 1964. *Courtesy Steve Kott.*

Steve Kott, a student at nearby Wayne High School, first met Russ Gibb through their involvement in the CAP. Their Great Lakes CAP unit drew cadets from a number of west-side schools. Its drill team, which Gibb coached and Kott was a member of, won national drill competitions in 1962, 1963 and 1965 representing the Michigan Wing.

In the fall of 1964, Major Russ Gibb recruited fourteen-year-old Jim Pudjowski of Dearborn for his award-winning Civil Air Patrol drill team. The team had the opportunity to visit the U.S. Air Force Academy in Colorado Springs, where the members were exposed to the impressive grounds and the pressure of recruitment. Pudjowski recalled:

> *When we won the CAP championships we were told by our senior cadet at the Air Force Academy that we would be receiving applications to apply to the Academy. Russ said to all of us, "You don't want to do this. At this time in America's history you don't want to go to Vietnam." They told us we would be in flying airplanes and that we would not be killing people, we would be pushing buttons. We would be using technology. Russ explained, "NO! This is a corporate battle....This is not about democracy....This is all about big business." I really respect Russ for that, that he told us his opinion and set us straight.[9]*

Pudjowski elected not to apply to the Air Force Academy or enlist. A high draft number kept him out of Vietnam.

MAPLES JUNIOR HIGH

Coming from a working-class union family, Gibb eventually found conditions for teachers at Romulus less than ideal. Ever the instigator, Russ made an effort to organize a teachers' union. Promptly discharged for doing so, Gibb bounced back quickly, and by 1963, he was teaching ninth grade American history at Maples Junior High.

A *Detroit Free Press* from 1969 painted a picture of Russ teaching at Maples:

> *In class Uncle Russ becomes Mr. Gibb and the long hair that falls in disarray over his forehead combed out of his eyes and behind his ears. But besides that Russ spends the first two days of class explaining the whys and wherefores of rules and regulations. "I explain why they can't jump out of*

their seat anytime they want and why they shouldn't sharpen pencils during class," he says. "Mr. Gibb tells it like it is," says one of his ninth grade fans. "And he uses our type of language."

Each day when they enter class, students gauge his mood by the mood barometer he has hanging on the blackboard. "The kids have a right to tell me what mood they're in too," Russ says. He's the hippie they now call SIR at the bank, the man Rotaries and Lions clubs invite to lecture on drugs and the generation gap.

Russ's students all seem to have enjoyed his unconventional methods. Jim Pudjowski recalled how Russ strove to engage his students, treating them as thinking adults. "Russ once spent the whole class asking everyone, 'what does it mean to be a liberal?' And 'what does it mean to be a conservative?' Russ was the first to broach some very adult subjects."[10]

Ray Salinas recalled, "He was the first person that ever talked to me (and the whole class) about smoking marijuana. He said, 'One of these days, probably real soon, you're going to go to a party and somebody's going to offer you a marijuana cigarette." And all of our eyes just lit up! 'You'll have to make that choice, just make the RIGHT choice.'"[11]

Russ told the *Detroit Free Press*, "Teaching is a personal thing; it's a building of trust together. I would hope that they would have an opportunity to have several teachers like myself. I would hope too that they would have several that were strict, old-fashioned. Because one thing I sometimes feel sad about, I think that maybe the kids have underrated the value of tradition."

CALIFORNIA DREAMING

By 1966, Russ's Fordson pal Jim Dunbar was a well-established talk radio host in the San Francisco/Bay Area market at KGO AM. Russ recalled driving to the coast for Jim's summer wedding by car, paying cash for a new Ford Thunderbird (a memory discounted by the fact that Dunbar had been married since December 1958). Young Steve Kott from the Civil Air Patrol recalled their visit was by air in the spring of '66. Dunbar was already acquainted with rock concert promoter Bill Graham through his concurrent KGO television talk show. "Bill and I had a mutual respect for one another and I thought it would be of interest to Russ to go to the Fillmore. I wanted to introduce him to Bill Graham."[12]

Jim arranged for members of the Dunbar family, Russ and Steve Kott to make the trek down to the Fillmore Auditorium. Jim the jazz fan did not care much for the music: "I thought it was ridiculously primitive." The sound and the multicolored light show, which included a shocking, pulsing novel effect called a strobe light, impressed Russ. Gibb managed to corner Graham after the show and peppered him with questions about his operation. Satisfied that his new bespectacled friend posed no direct regional competition, Graham disclosed a number of facts and even gave Russ the phone number for the kids up in Berkeley who built his strobe light. Kott recalled Russ saying, "Geez, I could do this at home!" Steve also remembered them heading directly to Haight Ashbury to order two of the strobes that Bill Graham had mentioned. Russ was effectively researching the culture shift in San Francisco and networking with opinion makers from two major cities.

For Russ Gibb, this was the first of many trips to San Francisco and the start of a relationship with Bill Graham. The two networked for years afterward, sharing tips on agents or hot acts and even lending one another capital to secure acts or tours. What Russ foresaw was a way to bring the San Francisco model to his Michigan market.

Part V

CRITICAL MASS '66

The Detroit youth music scene in 1966 consisted in part of teen clubs like the Hideouts, the Chatterbox and any number of halls catering to the under-eighteen set. In the wake of the British invasion, pop music was evolving. It was growing and incorporating progressive self-contained acts with original material. Entrepreneurs like Bill Graham in San Francisco sought to fill the new demand for these acts. In the summer of 1966, after returning from his latest trip to San Francisco, Russ Gibb began in earnest to replicate Graham's successes. Finding a comparable Detroit space for a psychedelic dance/concert set a number of key personalities on a path to synergistic convergence.

THE SINCLAIRS

I wanted to come to Detroit and be in the city, where the things were happening.
—*John Sinclair*

In addition to Russ Gibb, there came a pair of creative Bohemians, one from Michigan's thumb and one from eastern Europe. Their respective journeys to Detroit were significant and important to the Grande's formula.

LENI SINCLAIR

Photographer and activist Magdalene "Leni" Arndt was born on March 8, 1940, in Königsberg, the capital of East Prussia (today Kaliningrad). In 1945, Leni and her family became refugees. Running from the advancing Soviet troops, they were settled in a tiny German village called Vahldorf, which later became part of East Germany. Leni spent most of her formative years in this hamlet. Before Leni left East Germany, her mother gave her two hundred East German marks. As they were only worth twenty West German marks, Leni had to spend the currency before exiting. "I bought a 'Taxona' a very little camera that took square negatives. It had a very nice, a very sharp lens and some of my favorite pictures were taken with that camera."[13]

At the time, Leni had no serious ambition for photography. The tiny camera that her mother thought impractical became a key to her lifelong

Leni Sinclair at an Au Sable river tourist cabin. *Photo by George Tysh; courtesy Leni Sinclair.*

passion. In 1958, at eighteen, Leni made her escape to West Germany, where she lived for one year preparing to immigrate to the United States.

Thanks to extended family that sponsored her, Leni arrived in Detroit on November 20, 1959. The au pair job her aunt had arranged was in Grosse Pointe, an eastern Detroit suburb. Once settled, Leni began pursuing her interests in photography, jazz, Beat poetry and the beatnik culture. The musicians of Detroit's fertile jazz scene became some of Leni's favorite photo subjects. "I was trying to find some people that I thought were like minded to myself, and it worked I met some Beatniks!"

In the summer of 1960, at a friend's urging, Leni took and passed the entrance exam for Wayne State University, and she started that fall. In

The Red Door Gallery, 1964. *From left to right, seated*: unidentified, Robin Eichele and Martine Algier; *standing*: George Tysh (with painting) and unidentified. *Courtesy Leni Sinclair.*

her time at WSU, Leni met poet George Tysh and writer Robin Eichele. George and Robin in turn introduced her to musician Charles Moore. In the summer of 1963, this group became keen on locating spaces to exhibit and perform their works.

Eventually, this group located a building suitable for its needs next to a car wash on Second Avenue near Prentis. Leni Sinclair recalled, "[It was] called The Red Door Gallery because we painted the door red. It was a storefront....People put on exhibits, shows, poetry readings....There was a time where beatniks put on 'happenings' to make the straight people think there was really something going on there! We had fun doing that."[14]

JOHN SINCLAIR

Poet and activist John Sinclair became the cultural ambassador who helped connect the Grande Ballroom to its target audience. By 1966, Sinclair was an arbiter of cool and a force of progressive cultural change.

Born on October 2, 1941, in Flint, John was raised in nearby Davison, Michigan, a rural, General Motors "bedroom community" of one thousand

John Sinclair at the Detroit Artists' workshop, 1252 West Hancock, 1965. *Courtesy Leni Sinclair.*

residents. As a teen, Sinclair had an epiphany the first time he saw a package rock 'n' roll show in Flint. There he saw a diverse crowd enjoying raucous music. A scene totally opposite his staid small-town upbringing. Upon graduating high school and having had a taste of Flint city life, young John had determined that a rural or suburban existence was not for him. He recalled:

In 1959, I went away to college to Albion College in Albion, Michigan, another very small town. I was there for two years, and then I couldn't stand it anymore. By that time, I was into poetry and jazz, and I wanted to be a beatnik. There was only one [beatnik] there, and I learned everything I could from him In '64, I came to Wayne [State]....I didn't want to go to Ann Arbor because it was a college town. I wanted to come to Detroit and be in the city, where the things were happening.[15]

Comparatively speaking, Detroit in January 1964 *was* happening, and John set about haunting the city's jazz clubs. Enrolled in Wayne State's American literature master's program, Sinclair also wrote for *Downbeat* magazine and developed his own poetry.

In April 1964, John Sinclair and Charles Moore met a petite German neighbor at their Forest Arms apartment building. Their new friend Leni Arndt had a camera, a fact the pair found quite fortuitous.

Marijuana use was an element of the beatnik culture that Sinclair became intimately acquainted with. On October 7, 1964, the Detroit Police Department (DPD) busted John and two friends for possession of marijuana during a sting operation. The event put Sinclair on the books of the DPD's infamous anti-communist "Red Squad" and marked the beginning of years of police pressure on him.

12
THE DETROIT ARTISTS' WORKSHOP

By the fall of 1964, John Sinclair had given up his studies to focus on his writing and the art community as a whole. To that end, Sinclair and his extended company, many from the now defunct Red Door Gallery, started the Artists' Workshop. Their first location was a house at 1252 West Hancock on the Wayne State University campus. The DetroitArtistsWorkshop.com documented the group's formation on its timeline:

> On November 1, 1964 poet John Sinclair, photographer Magdalene Arndt (Leni Sinclair), poet/filmmaker Robin Eichele, poet George Tysh, trumpeter Charles Moore and others formed the Detroit Artists' Workshop Society. This inter-racial group of like-minded artists brought together all the aspects of culture—writing, poetry, music, film, and painting—and lived and worked communally. They sought to create a space and situation where new music and ideas could be performed and exhibited outside the dominant university and mass culture surrounding them.

The group patterned their installation after friends in Toronto who were operating as the Bohemian Embassy, a group that was also self-sufficient and very do-it-yourself. Leni Sinclair described what this new collective was like: "The Artists Workshop just started with a bunch of informal get-togethers. Each person put in 5 dollars to begin with and we rented West Hancock. The first floor was the Artists' Workshop and the Second floor was an apartment where Robin Eichele and Marty Algier lived."[16]

During this period, the workshop operated independently from Wayne State, free from censorship or any other restrictions. It became a nexus of progressive art and an independent cultural outlet. Eventually, the workshop did leverage WSU resources. John Sinclair recollected:

> We [also] *formed the Wayne State University Artists' Workshop Society so we would have access to the spaces, the venues on campus. We would put on concerts at Community Arts Auditorium or Upper DeRoy Auditorium. I remember Allen Ginsberg came down one time. Not anything commercial it was all ART, so it was all free in other words. Commerce was an anathema. Every Sunday afternoon we had a service. We also mimeographed poems and passed them out. We would only give them to people who looked "interesting." "Squares" wouldn't get any. We didn't want any squares, they had everything else. We wanted something of our own.* [17]

Although Hancock Street had limited space for musical performances, Charles Moore brought his group, the Detroit Contemporary Four (DC4), to the scene. The DC4 were Charles Moore (trumpet), John Dana (bass), Sandy Spencer (drums) and Ron English (guitar). They later added Larry Nozero on sax to become the DC5. Sinclair reflected further on the different types of art offerings:

> *The workshop had become a central force in the city's creative community. Weekly free jazz concerts, poetry readings and art exhibits, experimental arts classes and workshops, a steady stream of mimeographed flyers, poetry books and magazines, a series of campus concerts and other activities designed to bring art to the people had made the workshop a popular gathering place for area bohemians and cultural activists of all stripes.* [18]

On June 12, 1965, John Sinclair, age twenty-three, married Magdalene "Leni" Arndt, age twenty-five, in Detroit, Michigan.

13
THE MC5

Lincoln Park combo the MC5 had been paying its dues at VFW halls, school dances and record hops like WKNR's *Keener Karavan* since early 1965. The name MC5, although ostensibly meaning the Motor City Five, was partly chosen because it also sounded like a cool part you would order for your hot rod—an MC5 gear shifter or the like. The group's material was a mix of cover tunes and its members' own compositions. Their eclectic tastes, work ethic and desire to innovate soon served them well. The group became a musical pivot point for entertainment at the Grande over the following six years. "They told me that had been listening to Coltrane, Ornette Coleman, Pharoah Sanders and Eric Dolphy and that they wanted to take their music in a different direction. They called what they were doing 'Avant Rock,'" recalled Jerry Goodwin on wknr.com

By January 1966, the definitive lineup of the MC5 solidified. It consisted of Rob Tyner (Derminer), vocals; Wayne Kramer (Kambes), guitar; Dennis A. Thompson (Tomich), drums; Michael Davis, bass; and Frederick Dewey Smith, guitar. The entire band at this time lived in the Warren and Forest neighborhood, with junior member Dennis Thompson enrolled at WSU studying physics and engineering. Their neighbors were students and members of the Detroit Artists' Workshop, which was seeing something of a downturn.

In February 1966, John Sinclair received a sentence of six months for his August 1965 arrest for marijuana possession. During his imprisonment, the Artists' Workshop struggled and lost momentum. John Sinclair surmised, "I guess the watershed was when I went to prison for the first time. I went to

the Detroit House of Corrections (DEHOCO) for six months for marijuana in '66 from February to August. During that time, a lot of things changed around here, a lot of the people—the poets, the painters at the workshop had moved on to other cities or had gone on to something else."[19]

Leni Sinclair further clarified: "During that time while he [John] was in DEHOCO…the Artists' Workshop kind of fizzled away. In the summer of 1966, the world had turned…and things started happening that weren't happening before….The culture just exploded in all directions."[20]

Artist Gary Grimshaw in Russ Gibb's Grande office, circa 1967.
Courtesy Steve Kott.

One of MC5 member Rob Tyner's best school friends was an artist named Gary Grimshaw, who enlisted in the navy after graduating from Lincoln Park High. Stationed aboard the USS *Coral Sea*, Grimshaw spent the last six months of his two-year hitch in the Port of San Francisco. On shore leave, Gary studied the poster art and visual light shows at the Fillmore Auditorium and Avalon Ballroom. Once discharged in June 1966, Gary brought this knowledge and experience back to Michigan and the Warren Forest neighborhood. There he reacquainted himself with the WSU campus and his pal Rob Tyner. For the first time, Gary met and heard the latest incarnation of the MC5. Through this connection with the band, he soon had the opportunity to unveil his own innovative art work.

A FESTIVAL OF PEOPLE

A Summer Ecstasy in the Contemporary Arts

After a mysterious fire destroyed the 1252 West Hancock house, a former dentist's building at 4857 John C. Lodge Service Drive became the new Artists' Workshop location. In the summer of 1966, Leni Sinclair and the remaining members of the Artists' Workshop began to plan a party. John's release from DEHOCO was pending, and a celebration was in order. The final events of Sunday, August 7, 1966, though ultimately anticlimactic, marked the first event involving the Sinclairs and the MC5.

Leni reflected on this milestone happening: "We had one last blow out which we called the Festival of People to welcome John back to the community, which was like an all-day festival of poetry, music and dance at the Artists' Workshop. The last band that played that night was the MC5. That was a pivotal moment. The Artists' Workshop turned into Trans-Love overnight. Metaphorically speaking, because that's when the rock 'n' roll came into play."[21]

The $1.50 admission to the festival at the John C. Lodge building bought you poetry, dance, films and music from the Detroit Contemporary Four and the Lyman Woodard Ensemble. The MC5 was not officially on the bill. The group members (more or less) invited themselves and waited all day in the heat for their chance to play. They figured if John Sinclair dug them, that he might find them space to rehearse and perhaps advance their careers via his Wayne State Artists' Workshop and music industry connections.

The group played once all the poets had finished their readings; it was well past one o'clock in the morning. After only a few songs, Sinclair, tired and stoned, wandered off to bed. A short time later, Leni Sinclair pulled the power, bringing the day to an abrupt end. "John sent Leni down to have them stop playing so that the police wouldn't come and send him back to jail!" revealed Gary Grimshaw.[22]

The shocked MC5 realized their efforts at a showcase had been in vain. They had been unceremoniously censored—and by a group of beatniks no less!

Rehearsal Space

Although John Sinclair did not have an opportunity to properly evaluate the MC5 that night in August, it appears that he did evaluate the group by the time Labor Day passed. Having finally seen a proper MC5 show, Sinclair softened his jazz-purist stance. Hearing a parallel between the band's original music and his beloved free jazz, John also appreciated the band's knowledge of jazz and R&B. In September 1966, Wayne Kramer returned to the John C. Lodge building seeking a place for the MC5 to rehearse. Their new ally Sinclair granted permission, provided they rehearsed only during the day. Regular rehearsals began in earnest.

14
SETTING THE STAGE

*The Grande Ballroom was created to service the hippie community that
was small but burgeoning.*
—*John Sinclair*

Gibb had visited a number of properties, including the Statler Hotel
Ballroom and a few mothballed movie theaters, before he happened past
the Grande Ballroom. Russ had positive memories of his family dancing
there years before, but he was nearly too late in securing the property.

The *Detroit Free Press* reported that in the spring of 1966, the Grande second
floor was already operating (possibly underwritten by Glantz and Kliman)
as the Soul City U.S.A. Ballroom, hosting events and union fundraisers
within the African American community. By June, WJLB deejay "Frantic
Ernie" Durham had sublet it as the Celebrity Dance Hall. Durham's Friday
and Sunday night dances had further damaged the ballroom and upset the
neighbors. "Neighbors and members of the Northwest Council for Better
Recreation, a civic group, said the dance hall encouraged rowdyism, drinking,
gang fights and vandalism in the neighborhood."[23] The city shut down the
operation for lack of a proper license within a couple of weeks. The Grande
was indeed looking run down. Gaudily painted walls rimmed the scarred
dance floor. The roller rink skates were stacked in a basement storeroom,
and retail tenants were warehousing mattresses and paint upstairs.

Gibb made his pitch to a pair of landlords weary of their recent tenant
experience. Fortunately, Attorney Glantz was a frustrated musician who had
already owned and operated a number of entertainment properties. Given

proper management, he still saw potential. Soon Gibb had a fresh "lease with option to buy" agreement, and for $700 a month, Russ was ready to enlist others to help engage an emerging youth scene

To draw up the incorporation papers and prepare for any legal hassles ahead, Russ enlisted his old high school chum Roger Craig. Russ had been Roger's client since 1956, and his new law partner, Bernie Fieger, was a Harvard graduate. In 1964, the firm of Craig and Fieger had just hung its shingle on a renovated old house on 10 Mile Road in Southfield. The partners were champions of the civil rights movement at its most critical time. As members of the Freedom Riders, they made trips to Mississippi to try cases pro bono and register African American voters. The duo were ideal allies in fighting the conservative city of Detroit administration and police force.

Grande owner Gabe Glantz was already familiar with the aggravations of dealing with a progressive entertainment business in the city of Detroit. He knew the operation would suffer constant pressure and hassles from the police and the neighbors. Hard-nosed and well-connected, Glantz's regular on-site presence rounded out the legal team and gave Gibb a level of protection unmatched for a Detroit music promoter.

Russ's "ads for work" barter arrangement with WKNR had started while he was still doing his record hops. Knowing well the power of radio, he leveraged an extended network of radio personalities in the Detroit market. His friend and fellow WKNR jock Dick Purtan had also been capitalizing on the youth market outside the radio booth. Dick had booked the Beatles for Cincinnati simply by calling manager Brian Epstein's NEMS office in London and wiring a deposit. Purtan had become a great resource for Russ in all his promotion and media endeavors. In trying to keep expenses to a minimum, Russ limited newspaper advertising to small ads run in the *Detroit News*, *Free Press* or college and underground papers. Where possible, Russ tried to influence his press contacts to run small pieces on his ventures.

UNCLE RUSS'S TRAVEL AGENCY

Russ Gibb had spent his '66 summer school break enlisting friends, family and former students to his cause. By August, he still faced the challenge of booking live bands on a regular basis at the Grande. The simplest approach would be finding a local band with original material to book into a semi-

permanent residency. Although the exact sequence of conversation is lost to the ages, Russ started by tapping his Rolodex of contacts.

WKNR on-air talent hosted record hops and battles of the bands that occasionally booked the MC5. WKNR disc jockey Jerry Goodwin told keener13.com, "Russ was also moonlighting at the station at the time and asked me about finding a house band for his new Grande Ballroom. It was a perfect time to put Gibb and the MC5 together."

Harvey Ovshinsky and his *Fifth Estate* newspaper shared space at the John C. Lodge building with the Artists' Workshop and the MC5. In the documentary *Louder Than Love,* Harvey recalled, "I remember Russ Gibb coming to my office; he said, 'I want to bring music to Detroit in the San Francisco style.' I was happy when Russ asked me to make some recommendations."

John Sinclair recalled, "I can see a picture of him pulling up in front of the Workshop in his Thunderbird. You know, which was pretty high quality for us, we were living in $20 dollar a month rooms! And he said, 'We need to find bands.'" Regardless who made the introduction, what is apparent is that the sum of Russ's inquiries had led him to the MC5's rehearsal space at the John C. Lodge building by September 1966.

What seems certain is that Gibb attended a rehearsal of the MC5 for a private audition and he realized that the band fit the bill perfectly. The members were local, willing and, most importantly, played original material. Russ committed to them immediately. He planned to book them, through his new corporation, Uncle Russ's Travel Agency. Russ's veiled drug reference moniker appeared on much of the Grande's printed material and served to create a bit of underground street credibility for the brand. Russ explained to MC5 members that since he was operating on a shoestring budget, he would not be able to pay the band immediately. He assured them they would be the house band and that compensation would increase once the business took off. The group accepted, its members thrilled that they would be part of this new undertaking.

Shortly after Russ Gibb had gotten the cooperation of the MC5, Rob Tyner and Gary Grimshaw were lounging one afternoon at Rob's apartment. The phone rang; on the other end was Russ Gibb, who explained to Rob that he was in need of someone to create a poster for the Grande's grand opening. Tyner handed the phone to Gary, saying, "This call's for you." Russ gave Gary the copy, and he immediately stayed up all night creating the famous seagull poster. The seagull poster was the first of many that distinguished the Grande Ballroom from all other venues. Gary's work became the prime

Detroit example of the rock poster art form. Gary received a twenty-five-dollar flat rate per poster. Gary's uncle Ivor "Dave" Davison was co-owner of Crown Printing, the prominent local print house. Crown printed the majority of the Grande's printed materials over the next three years. Gary's Grande poster artwork became some of the most collectable pieces of the period. John Sinclair recalled the Warren-Forest neighborhood turning on to new art forms and to Gary Grimshaw: "When somebody would move into the neighborhood and they did something interesting you would know it right away. Wow, who is this? And then you would find out he's doing a poster for the Grande, the opening 'Seagulls Admitted Free.'"[24]

THE FINLY BOYS AND THE McDONALD'S DROPOUTS

Rosedale Park was a well-manicured subdivision on Detroit's northwest side in 1966. Musicians Jon and Steve Finly grew up on Lancashire Street a few blocks away from Warwick and the home of young Theodore Nugent. Jon Finly had started the Lourdes, of which Nugent was a member prior to forming the Amboy Dukes. Both brothers had met Russ Gibb roughly two years before the Grande's opening from playing at or attending one of the dances he promoted. At age eighteen, John had left the Lourdes and moved to San Francisco to be part of "the movement." While there, Jon hung out with tourist Russ Gibb and company as they absorbed the scene. Back in Detroit, Russ took Jon and Steve to view the cluttered and shuttered Grande Ballroom building. Once conscripted, the pair soon became fixtures of the operation.

From the beginning of his time as a promoter, Russ used printed materials as a key aspect of his marketing mix. It was no accident that every young person involved was sharing and distributing these materials. One location became a center for such actions. Russ was good at identifying hubs of teen activity. He had a network of such places where he knew he could drop off the handbills, postcards or posters for his events. In the days before social media, this was a quick, cheap way to disseminate information. He name-dropped these kids and their hangouts on WKNR. This served to boost listenership, as kids tuned in to hear about themselves and to find out where they might catch some live music. Steve Finly recalled his favorite Rosedale Park eatery was such a hangout:

Russ Gibb at WKNR Studios, Dearborn, May 1969. *Courtesy Tom Wright.*

There was a McDonald's that opened at Grand River and Fenkell in the Grandland Shopping Mall. It was a fairly middle-class neighborhood, but that place became a hangout for a lot of reasons. It was like a mini celebrity McDonald's that drew kids in for miles around—especially after Russ started mentioning it on his radio show and the fact that Russ, a few friends, and myself, would hand out Grande posters and cards there. Nugent would come there, even Bob Seger on "hang out" nights. They would hand out fliers for their gigs and hit on the girls that hung out there. But it was mostly because of how Russ promoted the place that it got the name. Once he "coined" that name, it stuck. The kids there ended being like a mini-army of teens that would then take the Grande posters and postcards and spread them around their surrounding townships, neighborhoods.[25]

OPENING NIGHT OPERATIONS

FRANK BACH

Along with the Finly boys, Eastsider Frank Bach was another member of the small crew who helped prep, set up and initially operate the new venue. By default, Frank fulfilled a number of roles, including building manager, projectionist and announcer. Bach remembered a conversation with Russ regarding his early duties at the Grande:

Grande manager and announcer Frank Bach at the first landing on the entranceway stairs. *Courtesy Steve Kott.*

Well, I got enlisted....He [Russ] said, "Okay, we need someone to open up the Ballroom early for the bands to come in and set up," and I said, "Okay, I'll do that." $40 a weekend to do that, like two nights a week and stay all night and then probably locked up at the end. You know, being around to help the guys unload and do other little chores. So he said, "We'll call you the building manager." I remember the first night, the MC5 played there and Russ was like reticent to bring them on. Although I knew Russ had a great radio show and talked on the radio, for some reason he didn't want to get out there and be the announcer. [26]

STEVE KOTT

Steve Kott had witnessed the San Francisco scene firsthand while on junkets with Russ Gibb in early 1966. Since then, he had been on the short list of the startup kids, which also included another Romulus Civil Air Patrol cadet, Larry Feldman. One of their first jobs was dealing with the loud paint colors

Steve Kott in Russ Gibb's Grande office, circa 1967. Courtesy Steve Kott.

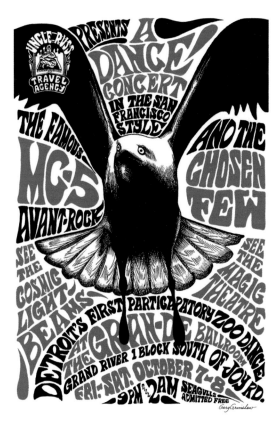

Left: Grande Ballroom "Seagull" inaugural poster, October 1966. *Art by Gary Grimshaw.*

Below: Belle Isle Love-In, April 30, 1967. Pictured here are an unidentified man (left), Russ Gibb (center) and Steve Finly (right). *Courtesy Steve Kott.*

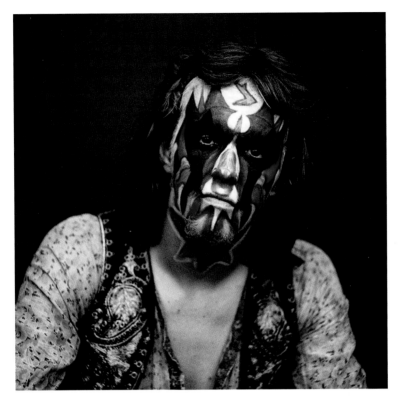

Dave Miller, Grande master of ceremonies, circa 1968. *Courtesy Tom Wright.*

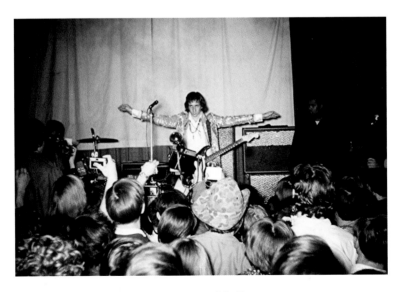

Pete Townsend of the Who, 1968. *Courtesy John Brown.*

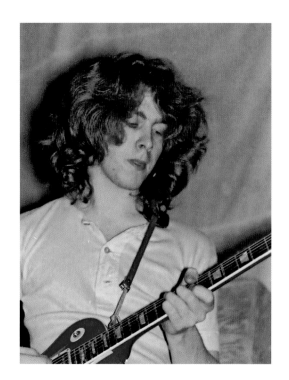

Mick Taylor of John Mayall and
the Bluesbreakers, October 1968.
Courtesy Jim Price.

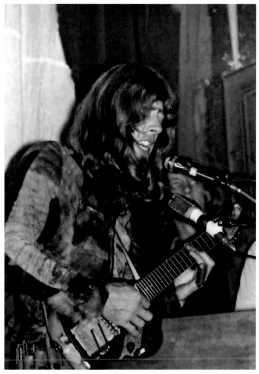

John Mayall, October 1968.
Courtesy Jim Price.

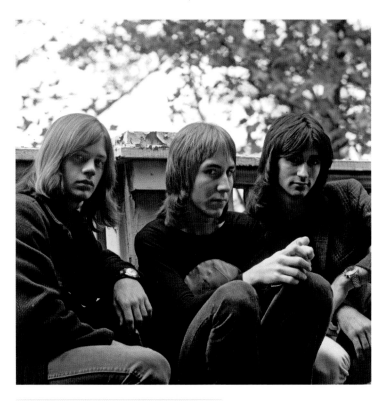

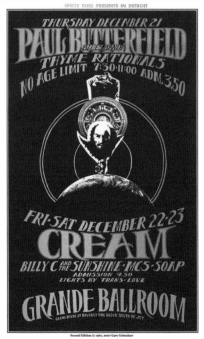

Above: Sky's *Don't Hold Back* album cover photo, 1970. *Courtesy Russ Gibb.*

Left: "Ming the Merciless" Grande Ballroom poster. *Art by Gary Grimshaw.*

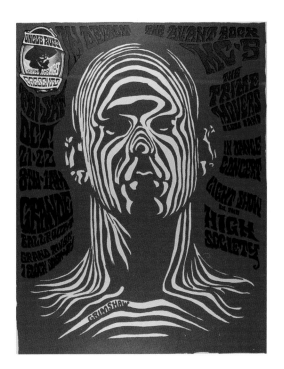

"Zebra Man" Grande Ballroom poster, October 1966. *Art by Gary Grimshaw.*

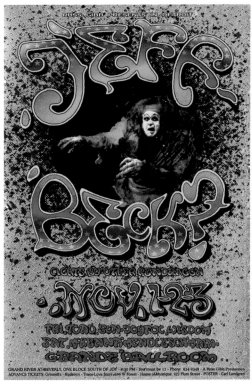

Jeff Beck Group Grande Ballroom poster, November 1968. *Art by Carl Lundgren.*

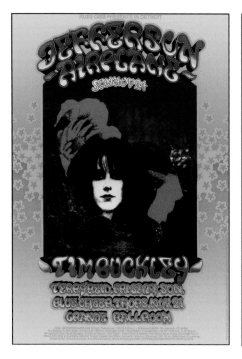

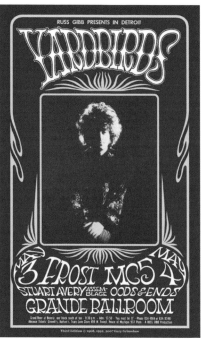

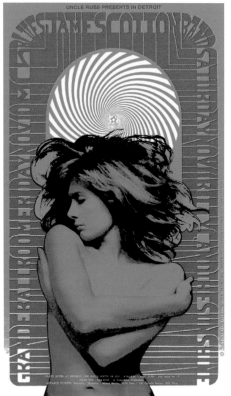

Above, left: Jefferson Airplane Grande Ballroom poster, November 1968. *Art by Carl Lundgren.*

Above, right: The Yardbirds Grande Ballroom poster, May 1968. *Art by Gary Grimshaw.*

Left: "Vanessa" Grande Ballroom poster, November 1968. *Art by Carl Lundgren.*

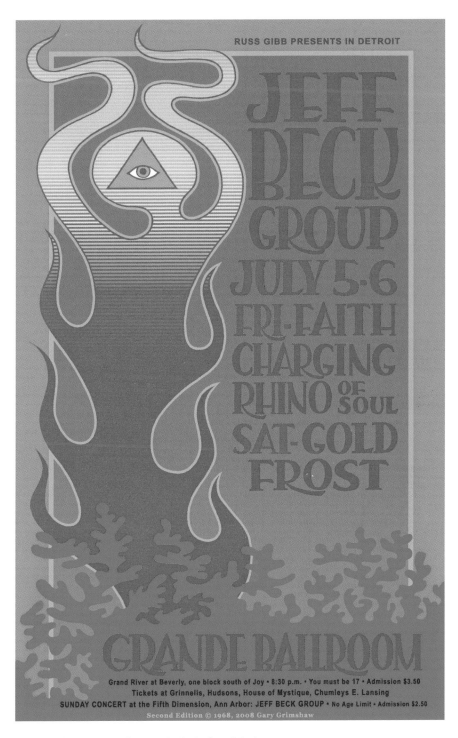

Jeff Beck Group poster, July 1968. *Art by Gary Grimshaw.*

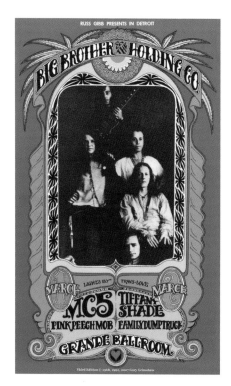

Left: Big Brother and the Holding Company with Janis Joplin Grande Ballroom poster, March 1968. *Art by Gary Grimshaw.*

Below, left: Clear Light Grande Ballroom poster, January 1968. *Art by Gary Grimshaw.*

Below, right: "Creamsicle" Grande Ballroom poster, October 1967. *Art by Gary Grimshaw.*

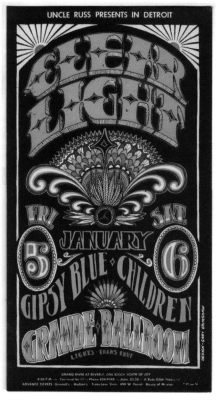

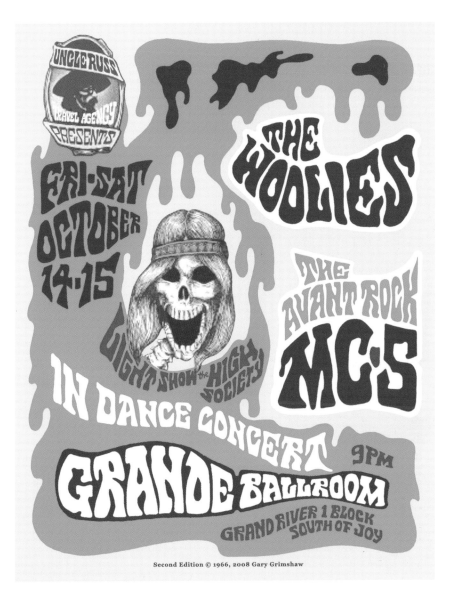

The Woolies Grande Ballroom poster, October 1966. *Art by Gary Grimshaw.*

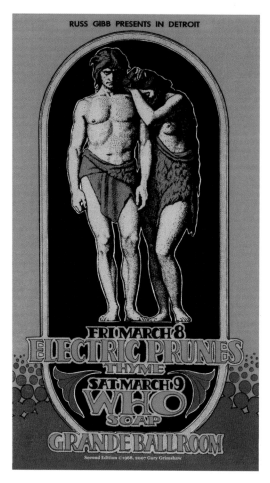

Left: The Who's Electric Prunes Grande Ballroom poster, March 1968. *Art by Gary Grimshaw.*

Below: The MC5 at Mount Clemens Raceway, Mount Clemens, Michigan, 1969. *Leni Sinclair.*

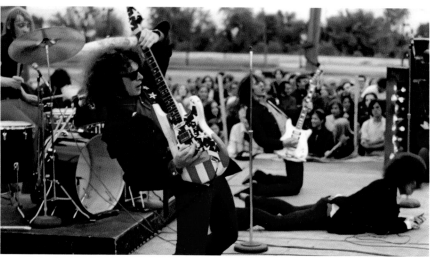

Above: The Jeff Beck Group, July 1968. *From left to right*: Rod Stewart, Ron Wood, Jeff Beck and Micky Waller. *Courtesy Ruth Hoffman.*

Right: Eric Clapton sitting in with John Mayall, October 12, 1968. *Courtesy David Hichman.*

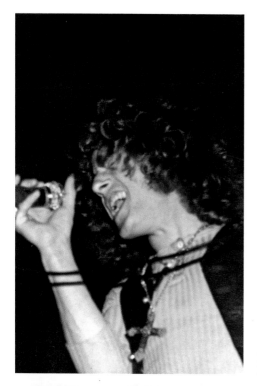

Roger Daltrey. U.S. "Tommy" Debut, May 1969. *Courtesy Jim Price.*

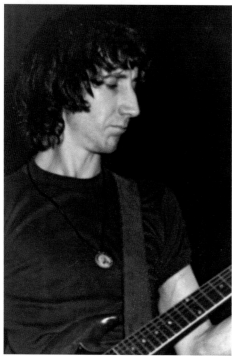

Pete Townsend. U.S. *Tommy* debut, May 1969. *Courtesy Jim Price.*

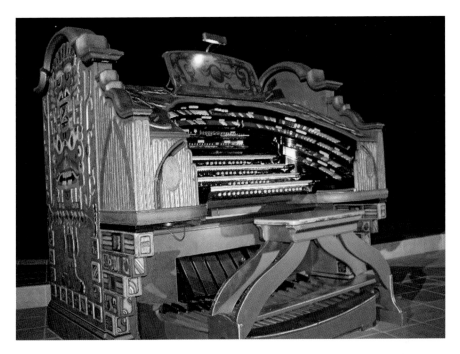

The Senate Theater's Mayan Revival Wurlitzer organ (Graven and Mayger design). *Author's collection.*

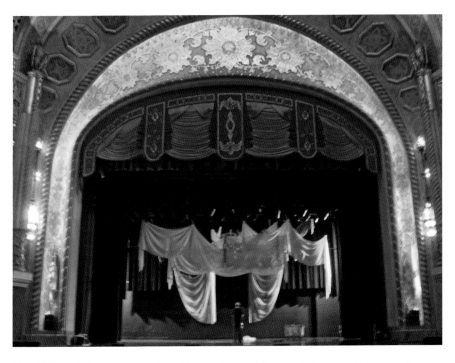

The Alabama Theater proscenium, Birmingham, Alabama, designed by Graven and Mayger architects. *Author's collection.*

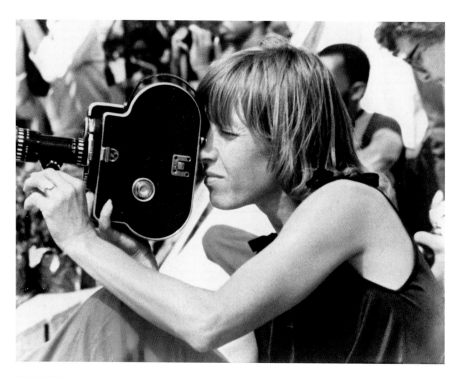

Above: Leni Sinclair at the Montreux/Detroit Jazz Festival, 1980. *Photo by Ed Hancock; courtesy Leni Sinclair.*

Left: Knights of the Grande "I Survived the Grande" Masonic Temple Crystal Ballroom poster, 2005. *Art by Howard Fridson.*

Russ Gibb and emcee Dave Miller at the Grande Fortieth Anniversary Concert, Royal Oak Music Theater, October 7, 2006. *Courtesy Susan Adams.*

"A Great Day at the Grande." The forty-third-anniversary gathering took place on October 7, 2009. *Courtesy Brita Brookes.*

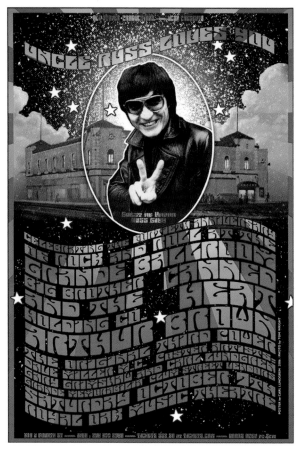

Above: The "fourth power" Third Power at WHFR studios promotional appearance. *From left to right*: Drew Abbott, Jim Craig, Jem Targal and author Leo Early. *Author's collection.*

Left: "Uncle Russ Loves You" Grande Ballroom Fortieth Anniversary Concert postcard, 2006. *Art by Carl Lundgren.*

from the roller rink and Soul City. "We painted the walls white. The carpet was still really neat; it had nice designs in it," Kott explained.[27] Once the cleanup/fix-up tasks were completed, Gibb put Steve in charge of the snack bar concession, for which Steve got a small salary and a percentage. The local Pepsi distributor bent over backward to be a supplier, providing signage and branded paper cups. With the bar up and running, cash and coins were shuttled by Steve Glantz (son of the owner and future promoter) downstairs to the ticket office. There Steve's grandfather Irv Kliman counted every nickel, dime and quarter. Kliman was the classic stereotype of the Jewish grandfather, complete with a thick brogue and omnipresent cigar. Kott remained snack bar manager until his draft number came up in March 1968.

MAGIC VEIL

Light shows were a critical component of the psychedelic ballroom formula. Operators superimposed oil and water amoebas over still images and grainy 8-millimeter films, creating a unique experience. Detroit Artists' Workshop member and "Detroit's first hippie" Jerry Younkins had developed a light show he dubbed the Magic Veil, which was demonstrated to Russ Gibb at the time he auditioned the MC5. Younkins taught Artists' Workshop members and other Grande employees to perform this light show. Gary Grimshaw, who had taken notes in San Francisco, was qualified to provide the liquid oil projections. The crew had scoured secondhand stores for antique crystal cake plates. Overhead classroom projectors shone light through various oils and food coloring mixed on these plates. Photographer Leni Sinclair and filmmaker Emil Bacilla specialized in the image projection, utilizing mostly slides and old classic and German expressionist films. Frank Bach and Robin Summers also operated the equipment, some of it clandestinely borrowed from the Dearborn public school system. Functioning from a six-foot-high wooden platform at the rear of the dance floor, as many as five of these artists projected their images onto the newly whitewashed walls and movie screens/bedsheets. In the summer months, temperatures on the platform could exceed 115 degrees, and the modest stipend they received barely covered the cost of materials they consumed. The spectacle they created kept people coming back. Eventually, through attrition, other teams of illumination artists brought their own style and innovation to the Grande light show platform. Chad Hines and Clyde Blair, billed first as the High Society then later as Luther Pendragon, were a duo who favored Mod

Harvey Ovshinsky and Jerry Younkins at the Artists' Workshop at the John C. Lodge service drive and Warren Avenue, circa 1966. *Courtesy Leni Sinclair.*

Magic Veil business card. *Art by Gary Grimshaw; courtesy Jerry Younkins.*

clothes and newer techniques, eschewing the 8-millimeter film projections. Clyde explained how their light show evolved: "We had gone to a lot more static images sort of a quasi-3-D, really utilizing those walls because lighting

the bands, you couldn't see anything, it blinded them. So we started using the sidewalls much more. We started doing what the walls dictated, this panoramic style that we started doing."[28]

Rounding out this innovative sensory experience was one of the strobe lights that Russ purchased in California. On cue, it could fire bursts of intense white light against the World War II–vintage twenty-four-inch mirror ball rotating on a motor. The dance floor at the Grande was a couple steps down from its encircling promenade. Grande regular Tom Gaff recalled negotiating that drop onto the pitch-black but mirror ball–lit dance floor. With the mesmerizing wall projections, the first step was like stepping out into space, a leap of faith. Gaff recalled, "Sometimes it felt like you weren't walking on anything from the effect it got out of you."[29]

JEEP HOLLAND

Hugh "Jeep" Holland was a University of Michigan alumnus and musical cognoscenti. In January 1966, Jeep was managing one Ann Arbor branch of Discount Records and had amassed an enviable record collection. Well plugged into the local college scene, he moonlighted as a booker and manager of local acts. Jeep started A2 Productions and grew a large stable of artists that eventually included Third Power, All the Lonely People, the Amboy Dukes, the Apostles, Frijid Pink, the Frost, the Jagged Edge, the MC5, the Children, the Rationals, Savage Grace,

Jeep Holland, circa 1968. *Courtesy Jeep Holland Papers, Bentley Historical Library, University of Michigan.*

Shakey Jake, the Scot Richard Case, the Stooges, the Thyme and the Wilson Mower Pursuit. A highly charismatic and intelligent character, Jeep

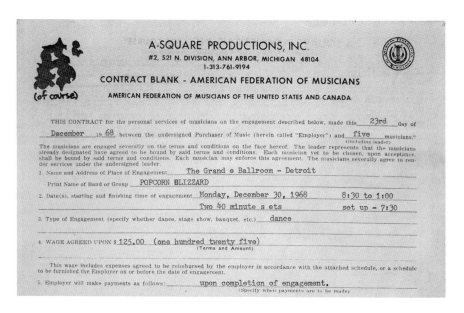

A2 Productions Popcorn Blizzard Grande Ballroom contract. *Courtesy Jeep Holland Papers, Bentley Historical Library, University of Michigan.*

introduced himself to Russ Gibb upon hearing of his new music venue. Ultimately, Jeep became responsible for booking a majority of the Michigan acts that played at the Grande Ballroom. His first talent sale came in the form of a group from Washtenaw County called the Chosen Few.

OCTOBER 7, 1966

I was just happy that it [the Grande] *was opening. I didn't have any interest in it except as a citizen. I thought now we got a place to go on Friday and Saturday night.*
—*John Sinclair*

In Emil Bacilla's famous photograph of opening night at the Grande 1966, you can see a small group of young people milling about the sidewalk or entering the building. Gary Grimshaw's seagull is in evidence on the far left, as are the brightly painted transoms over the doors. At far right, a group of four teenagers dressed for the occasion is in a small huddle. The average age this night was probably eighteen, with the only "oldsters" being Russ Gibb, thirty-five, and Gabe Glantz, forty-six. Certainly if you were over

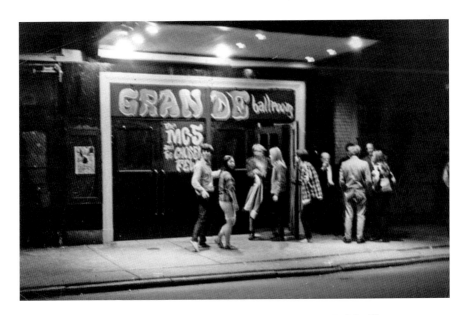

Opening night at the Grande Ballroom, October 7, 1966. *Courtesy Emil Bacilla.*

The MC5 at the Grande, October 1966. *From left to right*: Dennis Thompson, Michael Davis, Wayne Kramer, Rob Tyner and Fred Smith. *Courtesy Emil Bacilla.*

fifty, you had no business being at the Grande for this event, unless you had a concerted interest in the enterprise. Therefore, we can surmise the very short bald man immediately to the left of the huddle, in a jacket and tie with cigar in mouth, is very possibly Irv Kliman, Grande owner.

Initially Russ announced an opening date in late September, but preparations were still underway. The inaugural event moved to the first full weekend in October. Roger White recalls there being a soft opening where the bands tested the equipment along with the light show crew. Part of the delay may have been that Russ did not quite have the upfront cash or down payment for the lease-to-own agreement. Gabe apparently accepted something in lieu of that check so that Russ could get things started. Just what that accommodation was is open to speculation, but Glantz could have accepted a percentage of the door (ticket receipts) in lieu of a rent check.

Russ brought in a motorcycle to park on the first landing to the stairs coming in, the ticket-taker station. At one point, a claw-foot tub materialized in this position, when it was not magically migrating about the building. A number of novelties appeared all about the second floor for folks to discover, one attraction in particular Jem Targal recalled, "There was a table setup where they put a bunch of paper and fluorescent crayons and they had black lights hanging all over it too. So people would go over there and they would do these wild drawings. I ended up doing this drawing and they used to take the best ones and they would hang them up down the stairway to the entranceway. Mine was of the ones they picked!"[30]

You had to be seventeen and prove it, but after you paid your $2.50, you were up the stairs and into a world of wonderment. Drew Abbott of the power trio Third Power perhaps stated it best: "My life was in black and white like the opening scenes of the Wizard of Oz. Then I climbed up the stairs at the Grande, and as I set foot on the second floor, my life changed to Technicolor!"[31]

THE WHA?

Daniel O'Connell, bass/vocals
Tom Tasseff, guitar/vocals
John Milkovich, drums
Tommy Dempster, guitar
Bob Dempster, vocals

Around 1965, agent and manager Carnell Mickey got into booking bands into teen clubs and VFW's initially as a sideline. Carnell often worked with WGPR deejay Larry Dixon in hosting sock hops. Dixon had an enterprise called Club Mello, a club that featured membership cards, a soda pop

The Wha? load in at the rear of the Grande in October 1966. *Courtesy Bob Dempster.*

sponsor and a TV tie-in. The *Detroit Free Press* entertainment section for May 3, 1966, listed it: "A new musical variety show for teens will make its bow on WKBD-TV, channel 50. Larry Dixon is the host for the hour which will be seen live from the State Fair Coliseum. Saturdays at 7 p.m."

Dixon was already acquainted with Grande owner Gabe Glantz. According to Mickey, in early 1966, Larry hosted some of these weekly R&B pantomime teen record hops at the Soul City U.S.A. (Grande) Ballroom. Considering Dixon's commitment at the State Fair Grounds, these one-off dates must have occurred prior to May 1966.

Having already met Glantz via the Grande, Carnell Mickey also would run into Russ Gibb on the sock hop scene and at the Rosedale Park McDonald's. One of the acts Mickey was handling at the time had the peculiar name of the Wha? By the summer of 1966, members Dan O'Connell and the Dempster brothers, Tommy and Bob, became postcard conscripts of Gibb. Either through Carnell's familiarity with the venue or via the band's relationship with Gibb, it managed to get booked for opening weekend. Since the posters had already been printed, they did not receive billing. Nevertheless, the Wha? assuredly did perform opening weekend and several times thereafter.

Dan O'Connell wrote about their fateful encounter with Uncle Russ:

> *Dempster and I met Russ Gibb at Northland about one or two weeks before the Grande's first night. He had reams and reams of those Seagull posters. Gibb was handing them out at Northland, he hustled us, or we hustled him, into being an opening act for the first night....Perhaps, it was the second night, a Saturday. In any event it was to my recollection because the Chosen Few had broken up and canceled the show....Scott Richard was then forming (or fermenting), so we took one of the opening slots.* [32]

THE CHOSEN FEW

Scott Richardson, vocals
James Williamson, guitar
Ron Asheton, bass
Richard Simpson, guitar
Stan Salusky, drums

Some believe that sometime between Jeep committing the Chosen Few to the opening-night bill and Sunday, October 9, 1966, the group had broken up. What remains open for debate is whether the Chosen Few played at all. Author David Carson noted in "Grit, Noise and Revolution," "As a member of the Chosen Few, Ron [Asheton] had the distinction of striking the first note on opening night at the Grande Ballroom." Dan O'Connell of the Wha? is uncertain his group replaced the Chosen Few both nights. The Wha?'s Robert Dempster, fifty years later, disputes Asheton's claim

Despite the controversy over when they appeared, there is significant evidence of the Chosen Few playing at the ballroom through October. Offered as Jeep Holland's introductory act at the ballroom, the group was nearing the end of its run and soon splintered into the Scott Richard Case and the Psychedelic Stooges.

GOOD INK GOOD TIMES

The head count from the grand opening on Friday, October 7, 1966, varies widely depending on whom you speak to. Though heavily seeded by MC5 followers, Sinclair's Artists' Workshop members and the Wayne State crowd, only three to four dozen people managed to show up. Each attendee got a free pass, and the next night Saturday, attendance doubled. This effect did not directly repeat itself, but word of mouth about the Grande spread. By the end of 1966, Russ was still operating in the red, but he was optimistic.

On October 21, teen reporter Loraine Alterman of the *Free Press* gave the Grande a "Day-Gloing" review complete with several photos:

> *Pow! Wow! Bang! Zow! That's how the new op-pop scene at the Grande Ballroom hits you. No doubt about it—it's the grooviest, most exciting teen night spot in town. If you're 17 or over and don't hit the Grande on Friday or Saturday nights (8 P.M. to 1 A.M.), you are out of your skull. I don't mean to sound like a press agent for the place, but the Grande has that big, big spark of imagination that sets it apart from any club around.*

Gibb had certainly gotten the jump; his Grande, with a capacity of 1,500 plus, was larger than even the Fillmore Auditorium. Apart from New York's Electric Circus, other markets had not even come online yet with their own

psychedelic dance halls. Bill Graham's new Fillmores (West and East) would not start up until 1968.

MAJOR MARKET VENUE GRAND OPENINGS		
Detroit	Grande Ballroom	October 7, 1966
Boston	Boston Tea Party	January 20, 1967
Chicago	Kinetic Playground	April 3, 1968
Philadelphia	Electric Factory	February 2, 1968
New York City	Fillmore East	March 8, 1968
San Francisco	Fillmore West	July 5, 1968

Leni Sinclair offered an idyllic impression of what the Grande was like:

In the early days, in the beginning, it was almost like a clique of people that went there every night. And you'd see the same people, but just a few, it was not a huge crowd in the beginning. You know? And there was plenty of space for people to dance exuberantly under the strobe light, completely losing their inhibitions. It was just an exciting experience and exciting to watch there, people dancing around the ballroom under the strobe light. It was very mind blowing to me. And me, I grew up kind of repressed and kind of religious and never learned how to dance and wasn't allowed to wear any lipstick and stuff like that. The Grande Ballroom to me was a liberating experience, when you could do anything you wanted to do and have fun and just dance by yourself. You didn't have to sit there like a wallflower and wait for a man to come and ask you to dance, you know? Anybody could just be free and have fun....It was a place of liberty.[33]

Right from the start, the Grande provided the kids a lot of freedom. Barriers were removed; there was very little separation between the talent on stage and the audience. The acts usually entered via the same stairwell as the crowds did, and all were free to explore. John Sinclair offered a utopian viewpoint: "It was *the* place because you could demonstrate in action the things that were turning you on. The lights, the strobe light, the mirror ball, the big dance floor, the bands wearing colorful garb with long hair and playing music that they had made up themselves, sprinkled with cover tunes. Nobody ever played all original stuff, but that was the idea."[34]

ACTS OF NOTE, 1966

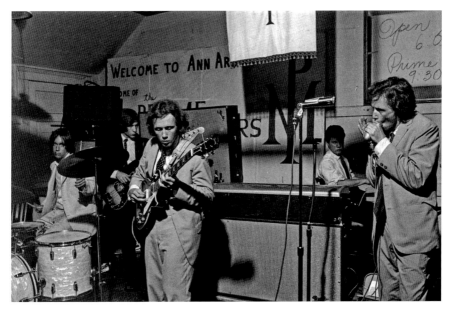

The Prime Movers No. 2, 1965 or 1966. *From left*: Iggy Osterberg, Jack Dawson, Dan Erlewine, Bob Sheff and Michael Erlewine. *Courtesy Michael Erlewine.*

THE PRIME MOVERS

Michael Erlewine, vocals, harmonica
Daniel Erlewine, lead guitar
Robert Sheff, keyboards
Robert Vinopal, bass
Jack Dawson, bass
Ron Asheton, bass
James Osterberg (Iggy Pop), drums
J.C. Crawford, drums

Ann Arbor's the Prime Movers had been working consistently since forming in 1965. The Erlewine brothers were blues purists and archivists who were not satisfied with playing "soda-pop" cover songs. Unlike the dozens of bands murdering songs by the British invasion groups, the Movers sought to master the roots music coming out of Chicago and the Deep South. "We would take frat gigs, but we never saw ourselves as a 'frat band,'" declared Michael Erlewine.[35] Their encounters with the Paul Butterfield Blues Band (which became their model) personally introduced them to many blues greats of the day. Booked by manager Jeep Holland, they were the first blues-based act to play at the Grande.

Erlewine believes that drummer James Osterberg (Iggy Pop) had likely left for Chicago by their October 21 Grande debut. Mike and the Movers had given Jim his nickname. Since his former group was a frat band called the Iguanas, they first called him "Iguana," which later became shortened to "Iggy." Iggy's replacement on drums was J.C. Crawford, who later developed an association with Trans-Love Energies and the MC5. As their resident emcee and "hype man," he is famously heard introducing the band on their 1968 album recorded live at the Grande.

THE BOSSMEN

Dick Wagner, lead guitar, vocals
Mark Farner, guitar, bass, vocals
Warren Keith, piano, vocals
Lanny Roenicke, bass, vocals
Pete Woodman, drums

The Bossmen, 1966. *From left to right*: Dick Wagner, Pete Woodman, Warren Keith and Lanny Roenicke *Courtesy Susan Michelson/Dick Wagner.*

Having your own record was a good way to get premium gigs in 1966. The Bossmen's single "Baby Boy" (*Lucky Eleven*) was a calling card. That record and their association with Jeep Holland secured the Saginaw, Michigan–based group a slot at the Grande on November 4, 1966. It was the first time on the Grande stage for both Dick Wagner and Mark Farner. Wagner went on to form the Frost, and Farner salvaged the remains of Terry Knight and the Pack to form the hugely successful Grand Funk Railroad. Grand Funk became one of Capitol Records' biggest sellers of the early 1970s.

GIVE THE PEOPLE WHAT THEY WANT '67

Give the people what they want" is an old show biz adage. The start of 1967 saw Russ Gibb seeking to learn the tastes of his audiences and booking accordingly. Word of mouth remained important, and Gary Grimshaw created ever more adventurous promotional artwork to circulate via their "Postcard Army." The creative input from John Sinclair and company had also become invaluable.

17
ARTISTES

PETRI DISH

At the Grande, the crowds were still thin, and Russ was still operating in the red. The Grande reputation was building, however, and it had become the objective of many local bands to play there. As the bands developed, so did the crowds. Russ and Jeep took chances with these local acts, hoping to improve attendance. In the unreleased documentary "The MC5: A True Testimonial," Wayne Kramer called the ballroom a "petri dish" where the MC5 and other local musicians worked out original material on the Grande stage.

> *We were afforded the luxury of leaving our gear set up all week and being able to go in and rehearse in the actual performance space; it was huge for us being able to work with the sound of the ballroom. Of course, it was freezing-ass cold because you can't heat that place up in the winter all week, and so we'd be rehearsing with our overcoats on. Otherwise, the Grande was like the experimental lab for the MC5 in terms of figuring out what we sound like and what we wanna do with what the performance should look like and how to pace it and everything.*[36]

THE NEW SPIRIT AND SKY

Soon every neighborhood combo that had an electric guitar wanted a chance to play at the Grande Ballroom. Bernie Fieger, one of Russ's attorneys, had two boys in junior high and high school that were no exception. Russ graciously placed the boys on the bottom of a bill for April 22, 1967, with Manchild and SRC. Geoff Fieger reminisced about his debut at the Grande:

> *Because my dad was the lawyer, Russ let my brother and I play there. So, before I ever went there as a patron I played there, with a guitar strapped to me—a Rickenbacker 12-string. It was fun. I was nervous. I remember....I think I still had braces on my teeth....My brother, Doug Fieger, myself, John Corey, who most recently has been with the Eagles and Bob Greenfield. We had a group. We didn't call ourselves The Spirit because there was a California group called The Spirit, so we called ourselves The New Spirit, but all we played were Beatles songs and it was fun. I mean, it was my*

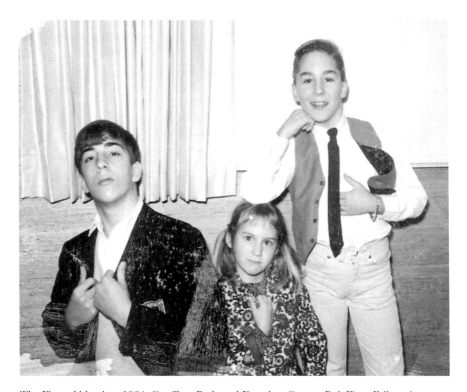

The Fieger kids, circa 1964: Geoffrey, Beth and Douglas. *Courtesy Beth Fieger Falkenstein.*

first experience at a big time thing with the stage lights, so you couldn't see the audience. But we sounded exactly like the Beatles.[37]

Doug Fieger and John Corey from the New Spirit eventually formed the trio Sky and would appear again at the Grande. Russ Gibb managed the new band, got them a recording contract and flew them around the world recording and performing. The group released two albums in 1970, *Don't Hold Back* and *Sailor's Delight*, both produced in England by Jimmy Miller, who had also worked with the Spencer Davis Group, Blind Faith and the Rolling Stones. Fieger later topped the charts with the power pop quartet "The Knack" (1979).

As another favor to Bernie, Russ Gibb gave Geoffrey a summer job running errands before he attended the University of Michigan and the Detroit College of Law. He is today a noted defense attorney and legal commentator.

A2 PRODUCTIONS

Jeep Holland, having established himself as the primary booking agent for the Grande, presented two of his most significant acts in the first quarter of 1967.

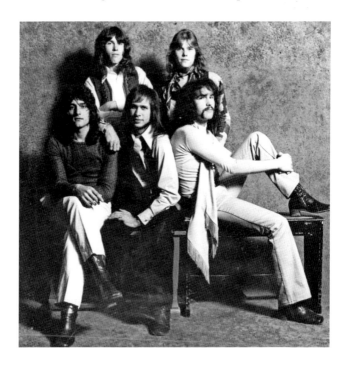

Scot Richard Case.
Courtesy Fred Bender.

The Scot Richard Case (SRC)

Scott Richardson, vocals
Gary Quackenbush, lead guitar
Steve Lyman, lead guitar, vocals
Glenn Quackenbush, keyboards, vocals
Robin Dale, bass, vocals
E. G. Clawson, drums

Rising from the ashes of Ann Arbor's Chosen Few and the Fugitives, the Scot Richard Case played its first documented gig at the Grande Ballroom on January 21, 1967. Jeep's latest signing featured a dual guitar sound blended with a classically influenced Hammond organ backing. The group became regular favorites at the Grande and, in May 1967, released its debut single on Holland's A-Square label: "I'm So Glad / Who Is That Girl?" As it did with other acts, performing at the venue served to develop the band significantly. The group's singles generated more major-label interest than they did revenue, and the band signed to Capitol Records in 1968. By this time, they had shortened their name to SRC. After a number of iterations and notable LPs, the group had disbanded by 1973.

The Rationals

Scott Morgan, vocals, guitar, harmonica, piano, flute
Steve Correll, guitar
Terry Trabandt, bass, vocals
Bill Figg, drums

The season the Grande reopened, Jeep Holland had already produced and arranged a number of singles for acts on his roster. Holland knew well that having a 45 single got his bands more bookings.

Recording for Jeep's A2 Label since 1965, fiery blue-eyed soul singer Scott Morgan and the Rationals had a top 100 hit with Otis Redding's "Respect." In November 1966, the record was strong enough for Cameo/Parkway to distribute it nationally, and the attention got the group better money and better engagements. The Rationals rode this wave of success into the ballroom on February 11, 1967, and consistently drew good crowds thereafter, eventually performing at the venue over sixteen times. Scott Morgan explained their methods and influences to interviewer Jason Schmitt:

Because we were exposed to a lot of stuff and it wasn't just at the Grande, it was at the Roostertail and, you know, on CKLW television and everywhere. I think it started with the Beatles and then it went to The Who and to Jimi Hendrix, The Yardbirds and it just kept going, you know? We were exposed to a lot of stuff that really influenced us. We tried to, like pick up some really root stuff at the same time as we were picking up the Youngbloods. We'd be picking up Tennessee Ernie Ford and "Sixteen Tons." So we tried to combine a lot of different stuff and then writing our own material and combined that with the Rhythm and Blues roots that we had grown up with. Made a name for our self with "Respect" and "I Need You" and stuff like that. So we kind of had a combination of stuff going on.

Tim Buckley

It was the summer of love, but the summer of love didn't make a stop in Detroit.
—*Wayne Kramer*

Percussionist Carter Crawford "C.C." Collins had been touring with singer songwriter Tim Buckley since first backing him at Bard College in Annandale-on-Hudson, New York. While visiting a band of Bard student musicians who supported visiting pop and folk acts, Carter got a chance to play on Buckley's engagement. The school's combo included guitarist Walter Becker, keyboardist Donald Fagen and a drummer and future actor named Chevy Chase. Randomly, Collins was first to welcome Buckley, and the pair bonded over coffee before a brief audition at the campus chapel. After a short run-through, only Collins made the cut. (Becker and Fagen recovered and went on to form the legendary Steely Dan.) After the pair's two stellar sets at Bard, Tim commented, "I really like the way you play man," to which Collins responded, "Then why don't you hire me then?" Buckley did hire Collins for the remainder of his East Coast tour dates, and the two were soon working on Tim's new record in Venice, California.

Prior to World War II, northwest Detroit neighborhoods were principally white communities. Many businesses that supported these populations lined streets like Grand River and Livernois. By the 1960s, with the introduction of urban renewal, whites were leaving Detroit in large numbers. On the Eastside, the Chrysler Expressway construction ripped a one-hundred-yard-wide trench through a whole community. Some African American residents who called that Hastings Street neighborhood home migrated directly to

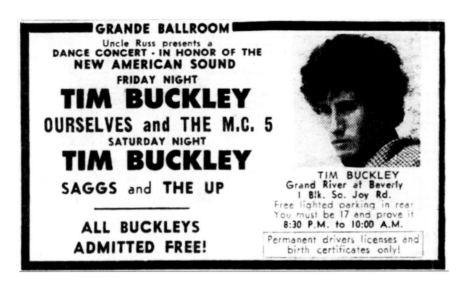

Tim Buckley ad from July 1967. *From the* Detroit Free Press.

the northwest neighborhoods. By 1967, the Grand River–Joy quarter was approximately 40 percent African American. Racism and police brutality had become more prevalent in this rapid demographic change, and quality housing was at a premium.

It was hot that July 1967 in Detroit, and despite the designation the "Summer of Love," conflicts and riots had already broken out in other American cities such as Los Angeles and Newark, New Jersey. Tensions, especially those with the police, made Detroit a tinderbox waiting to catch fire.

On the strength of his 1966 debut LP *Tim Buckley*, Jeep Holland and Russ had scheduled the twenty-year-old singer-songwriter for Friday and Saturday July 21 and 22. The MC5 and Ourselves were the supporting acts for Friday, with the Shaggs and the UP warming up the audience on Saturday. Tim's record sold well locally, and the throng at the Grande was appreciative that humid July weekend. On this tour, Buckley and his percussionist C.C. Collins were road-testing songs from the newly recorded (but unreleased) LP *Goodbye and Hello*, recorded the previous month in Los Angeles.

After a particularly sweaty show, or between sets in the non-air-conditioned Grande, it was often the custom to cool off and hang out on the large breezy roof of the building. After Buckley's Saturday show in the wee hours of Sunday the twenty-third, the staff and talent noticed an orange glow in the sky from the direction of Twelfth Street (today Rosa Parks Boulevard) and Clairmount. Unbeknownst to those present, the source of this glow

came from fires set by rioters one and a half miles to the northeast. The conflagration was kindled at the location of a blind pig raided by Detroit vice cops. John Lee Hooker sang about the events of that weekend in "Motor City's Burning." A track also covered by the MC5. The press labeled it a riot. Considering the degree of police oppression and substandard conditions dealt with by residents, many today still call it an uprising.

As Sunday dawned, Uncle Russ gathered some staff and his houseguests from the Tim Buckley show for a party at Kensington State Park, thirty miles west of Detroit. The entourage enjoyed barbecue and a brisk swim on a beautiful July day. As the afternoon progressed, everyone decided to head back to Russ's home in Dearborn. Russ's 1965 Thunderbird was legendary for its sound system, complete with an eight-track tape player. It was because of this eight-track that the group did not hear any radio news until its return to the city. As the group reached a police cordon on Grand River, the police informed the members of the events transpiring, and they detoured south. The smoke plumes they saw rising in the east suggested that a strategy was necessary to retrieve Buckley's equipment before dark. Assuming the ballroom was still standing, they needed to safely travel through the riot zone and back again.

Back in Dearborn, the small posse staged its mission at Gibb's bungalow on Kentucky Street. After a quick stop to rent a small U-Haul trailer, the group set out for the Detroit border. First, as they drove through the lily-white suburb, Russ, Tim and Rick Patrny rode in plain sight with Carter Collins hiding on the floorboards of the T-Bird. When they reached the Detroit city limits they switched, having African American Collins drive through the affected northwest neighborhoods. Collins later confessed, "What Russ didn't know was that I didn't even have a driver's license."[38] In fact, his vision problems prevented him from ever acquiring a license to drive. If stopped by the police, "it most certainly would have meant an ass-kicking," Collins recalled.

Within these early stages of the conflict in Detroit, the National Guard and U.S. Army had not yet deployed. Enforcement of the law was strictly in the hands of the Detroit and the Michigan State police.

As the riot spread, some African American business owners painted the words "Soul Brother" on their properties in the hope that they would be spared. This being the first twenty-four hours of the riots, the Grande had no such painted distinctions, affiliations or immunity. The reputation of the building, management's rapport with the neighborhood and the local merchants saved it. Ronald Fleming, whose father worked for Herman Moss and Associates Furniture store recalled, "My father and Herman Moss helped board that building up and kept the rioters from burning the building down."

Upon safely reaching the Grande that Sunday afternoon, Gibb was amazed to see the building still standing. Up and down Grand River, businesses were in smoldering ruins, yet the Grande was intact, virtually unharmed. The astonished party spotted some of the neighborhood kids whom Russ often offered chips, pop and free admission. As these boys ran by, Collins managed to grab one and asked him why the building was untouched, to which the boy replied, "You got music here man!"

At the conclusion of five days of rioting, the City of Detroit tallied 43 dead, 1,189 injured and over 7,000 people arrested. Buckley and Collins safely retrieved their equipment and continued on to a gig at the Troubadour in Los Angeles the following weekend. Tim's album *Goodbye and Hello* came out in August 1967. Tim Buckley died of a heroin overdose in June 1975; he was twenty-eight years old. Carter Collins has recorded and toured with the likes of Tower of Power, Richie Havens, Leonard Cohen and Stevie Wonder. Today, he lives in Hawaii, where he still plays and remains active in philanthropic and nonprofit causes.

THE UP

Frank Bach, vocals
Bob Rasmussen, guitar
Gary Rasmussen, bass
Victor Peraino, drums

Former Grande announcer/stage and building manager Frank Bach formed the UP in the spring of 1967. Bach had seen the level of local talent that played at the Grande and figured he could do just as well. The group's first date was a slot warming up Tim Buckley on Saturday night, July 22.

> *Well this would be really cool! I really liked music and hadn't played, didn't take lessons or anything, but you know, [I] started thinking, "Well, it would really be great to, based on what I know from watching these guys, it would be nice to be involved in the band." So we managed through these little connections with each other, my connection with the Grande and Jeep and stuff to call ourselves a band and get some gigs.*[39]

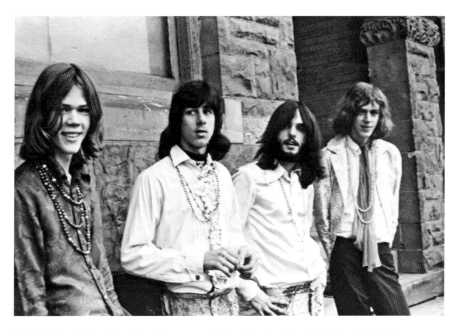

The UP. *From left to right*: Gary Rasmussen, Victor Peraino, Frank Bach and Bob Rassmusen. *Courtesy David Sinclair.*

Managed by John Sinclair's brother David, the UP, along with the MC5, became closely associated with the Revolutionary White Panther Party based in Ann Arbor. The group eventually released a limited amount of material in 1970, including the classic proto-punk single "Just Like an Aborigine," before breaking up in 1973.

FAR AFIELD

As the crowds at the Grande grew, so did the demand for new and more popular acts outside the local market. Gibb and Glantz worked their network of contacts and sought input from John Sinclair and Trans-Love Energies. The James Gang from Cleveland, Ohio, and the Fugs from New York City were the vanguard of a new list of national and international touring groups to play the Grande. These engagements marked a strategic shift in booking policy that required extensive negotiations with agents and management throughout the United States and the world.

The James Gang

By the fall of 1967, Cleveland, Ohio, still did not have a venue comparable to Detroit's Grande Ballroom. Buckeye bands looked north for happenings in the Motor City. Formed by Kent State students Glenn Schwartz and Tom Kriss, the James Gang's first gig on October 28, 1967, did not yet include Joe Walsh. The guitarist joined the band in January 1968 and appeared a half dozen times with the group at the Grande. Its first LP, *Yer Album*, debuted in 1969.

The Fugs

John Sinclair recommended the Fugs, from New York City, to Russ Gibb. He was already familiar with their controversial and unconventional recorded material and was anxious to have them on, considering their involvement in recent antiwar protests in Washington, D.C.

On October 21, the Fugs, along with activists Abbie Hoffman and Allen Ginsberg, led a chant to levitate the Pentagon and excise its demons, thus ending the U.S. involvement in the Vietnam War. Fugs member and poet Ed Sanders first read the exorcism rite:

> *In the name of the amulets of touching, seeing, groping, hearing and loving, we call upon the powers of the cosmos to protect our ceremonies in the name of Zeus, in the name of Anubis, god of the dead, in the name of all those killed because they do not comprehend, in the name of the lives of the soldiers in Vietnam who were killed because of a bad karma, in the name of sea-born Aphrodite, in the name of Magna Mater, in the name of Dionysus, Zagreus, Jesus, Yahweh, the unnamable, the quintessent finality of the Zoroastrian fire, in the name of Hermes, in the name of the Beak of Sok, in the name of scarab, in the name, in the name, in the name of the Tyrone Power Pound Cake Society in the Sky, in the name of Rah, Osiris, Horus, Nepta, Isis, in the name of the flowing living universe, in the name of the mouth of the river, we call upon the spirit to raise the Pentagon from its destiny and preserve it.*[40]

Several hundred people then chanted, "Out, demons, out!" The Pentagon reportedly never levitated, turned orange or vibrated the demons out. The Vietnam War also did not end overnight. The Fugs did, however, embark

on a tour of venues throughout the United States, including a November 24 stop at the Grande, where they shared such chestnuts as "Kill for Peace," "My Bed Is Getting Crowded" and "New Amphetamine Shriek."

The Cream

In the late summer of 1967, having had some success with a few larger national acts, Gibb decided to go out on a limb and book British super group Cream through the General Artists Corporation (GAC). GAC had been around since the 1940s and was one of the top-three artist talent agencies in the United States. Formed in 1966, Cream was touring to promote its second LP, *Disraeli Gears*, which would premier in November. Recorded in New York in the spring of 1967, it would become the group's breakthrough U.S. album. In three nights of performances, the Cream jammed before packed houses of 1,500 plus. Doc Greene, the middle-aged night beat reporter from the *Free Press*, even made it to the October 14 show:

> On Saturday night when I went out there, the cost was $3.50 a head which meant that you had to be a little psycho to attend. But not much. Uncle Russ Gibb, the guy who runs the Grande, explained their popularity in this country a little. "No disc jockey has ever played a record of theirs that I know of in the city," but a local outfit named Scott Richard Case stole their number "I'm so glad," and put out a record of that and it became a number one hit locally.

Guitarist Jimmy McCarty made it to Cream's sound check and the Sunday night all-ages show on October 15, 1967. McCarty remembers Eric Clapton testing out his Wah-Wah pedal through his wall of Marshall amplifiers: "That was the first time I ever heard a Wah-Wah used live, it was an incredible sound in the near empty Ballroom."[41]

Jimmy brought along a small two-track reel-to-reel tape recorder and got permission from Russ Gibb and the band to record the night's performance. He likely also had to get permission from Ben Palmer (Cream's road manager and piano player for Eric's former group the Roosters) to set up. The band was accommodating and gave Jim the OK in exchange for some "pick me ups" that he provided. McCarty set one microphone near the front of the stage and ran a direct signal cable from the PA system to the other available channel. Jim captured Eric Clapton, Jack Bruce and Ginger Baker stretching

out on extended versions of compositions from their yet-to-be-released LP. Many years later, Jim lost control of the original tape, and it has since resurfaced, remastered through international bootleg circles on CD. For the listener, it is an incredible record of the group and an aural fingerprint of how the Ballroom itself sounded. Here is the set that McCarty recorded that night: "Tales of Brave Ulysses," "N.S.U.," "Sitting on Top of the World," "Sweet Wine," "Rollin' and Tumblin'" "Spoonful," "Steppin' Out," and "Toad."

Rock poster collectors David Lawrence and Eric King in recent years acquired a Russ Gibb–penned Grande postcard sent to Cream's manager Robert Stigwood in London:

Mr. Robert Stigwood
NEMS
Sutherland House
5–7 Argyle St.
London W1 England U.K.
November 17, 1967

Dear Sir,

I understand you will be representing the Cream, the group did well for me here in Detroit I wish them back. What is your relationship with GAC now? If it is open, I should like to speak with you in regards to some ideas I have for the Midwest USA.

Thank you.
Russ Gibb

By 1967, Robert Stigwood had become a major figure in British entertainment talent management. He used his influence as the Who's booking agent to land a personal management agreement with the members of Cream. "Stiggy" had managed the Graham Bond Organization that provided Jack Bruce and Ginger Baker as well as John Mayall's Bluesbreakers, of which Eric Clapton was a member. He was a co–managing director and major shareholder in NEMS (North End Music Stores), Brian Epstein's management company. With Eppy's sudden death in late August, Stiggy hoisted himself to the top of his field. Moreover, he would be taking acts like the Who, Cream and the Bee Gees along with him. In November, Stigwood received a postcard from a promoter in Detroit, and the Cream was booked for the Grande Ballroom December 22–23, 1967.

PARTNERS AND STAFF

TRANS-LOVE ENERGIES

Fly Trans-Love Airways. Gets you there on time.
—Donovan "Fat Angel" 1966

The Detroit Artists' Workshop slowed with John Sinclair's 1966 incarceration. Artists' Workshop members merged or spun off into other organizations and bands. What remained was a commune and network operating under the Trans-Love Energies moniker. The Mixed Media Book store, the MC5, the Sinclairs and the Warren-Forest Sun all were integrated into the operation based at 4857 John C. Lodge Service Drive. "It was a new age development of hippie entrepreneurs," Leni Sinclair recalled. All of these individual entities came together not only to promote their individual efforts but also to advance a new, progressive form of culture. In early 1967, Trans-Love Energies incorporated as a Michigan nonprofit organization. John Sinclair explained the metamorphosis of the Artists' Workshop into Trans-Love Energies:

> *Then there are all these young people coming in from the suburbs who wanted to find something interesting to do. Go to college, go in the army or get a job* [were the other options]. *And of course from the Artists' Workshop to that period of about a year and a half, we were all taking psychedelic substances and having mind-expanding trips, learning the secrets of the universe. The things that we saw we thought were so important we*

wanted to tell everyone about them! We wanted everyone to know that it didn't have to be like this! We were so naïve. Trans-Love was more like a church, a proselytizing group; we wanted people to know about hippies.[42]

Trans-Love Energies people were now regular fixtures at the Grande. In addition to members being essential to the light show crew, a small shop counter was initially set up to sell handcrafted items by Leni Sinclair and company. Soon the shop offered beads, leather headbands and armbands, buttons, underground papers, mimeographed poetry books and magazines from the Artists' Workshop Press and avant-garde jazz records from the ESP catalogue. This Trans-Love store and George and Ramona Agee's incense stand tucked neatly into the recessed arches facing the stage. Already Leni was finding herself very busy, oftentimes too occupied to take photographs. Some nights, you could find her infant daughter asleep under the store's counter.

RICK PATRNY

Rick Patrny was yet another young man recruited by Russ Gibb for the Grande Ballroom. A recent MacKenzie High School graduate, Rick started out taking tickets seated in the claw-foot bathtub on the staircase landing. "I remember there was a mirror at the top of the stairs and they had two security guards there, Lloyd and 'O.C.' They would kinda stand at the landing there and make sure there were no problems."[43] At one point, the operation employed up to thirteen guards for events.

Patrny had begun his employment no later than St. Patrick's Day 1967. On that date, he met his future wife on those stairs in the same building her parents met at in the 1940s. Rick soon graduated to handling announcements and the record player from the ballroom stage. Patrny took over for Frank Bach, who had left to form his own band, the UP. For Rick, the Grande was an opportunity to "do some livin'" before his draft number came up. He stayed on through December, when he received his notice from Uncle Sam. His story was not unlike like many other draft-eligible young men who attended the Grande. Rick was one of the lucky ones; some drafted from the Grande tribe did not return stateside.

The "O.C." Rick referred to was the sizable African American Grande security guard with neat, processed hair and a gold tooth. Slow-moving, amiable and well-liked by the crowds and management alike, he apparently

had some level of tenure at the Detroit Police Department and was said to be a ringer for blues great Muddy Waters. At least a few of the "rent-a-cops" who Rick Patrny and others worked with at the Grande were moonlighting Detroit Police officers. Providing this income to the DPD was certainly part of the appeasement plan that Russ and Gabe had devised to keep the Grande open. At least this was money that could be budgeted for; at other times money for a "police fund donation" had to be found. For example, one Saturday, Russ Gibb (a noted clotheshorse) stopped into his favorite menswear store on Livernois, "the avenue of fashion." "Oh, Mr. Gibb," said the clerk, "those suits are ready for Lieutenant So-and-so." Russ was at first taken aback, puzzled that he did not remember ordering any suits. Having realized what had taken place, he paid to have them specially delivered to the officer. There was now one less shady, albeit well-dressed, police lieutenant to give the Grande any trouble.

As the Grande became more successful and started to operate in the black, the payouts did not end; more folks ended up on the payroll to keep things quiet and the Grande running smoothly. Mrs. Collins, the kind woman who owned the dual-income house immediately across the alley from the Grande, received a monthly stipend. Her only responsibility was to report to Russ if any of the part-time kids he hired to clean up the neighborhood were loafing. Rick Lockhart, an emancipated youth who worked for Gabe Glantz starting in 1968 remembered, "We paid the neighbors so they would keep everything good and nice for us.…There was a cash payment every single week that was hand delivered to them. To make it run that's how we had to operate."[44]

DAVE MILLER

Originally from Beaver Falls, Pennsylvania, David Kermit Miller moved to Birmingham, Michigan, with his family around 1965. By 1967, having been turned on to the new Grande Ballroom by a Seaholm High pal, young Dave had met promoter Russ Gibb and became one of his "Postcard Army." In exchange for distributing Grande promotional materials at schools, head shops and hangouts on his home turf, Dave received free admission to all events at the ballroom. By the fall of 1967, now a certified regular, Dave was offered the chance to live audition for the announcer spot as outgoing emcee Rick "Big Rick" Patrny was expecting to be drafted. Rick received his draft

notice in December, and Dave officially transitioned into the job. Known for his outrageous behavior, face makeup and antics on the microphone, Dave also augmented his appearance on stage with various masks and Native American accessories. Favorite pets, such as his prized eight-foot boa constrictor Buzzard King Orange, also made appearances, preceding and perhaps influencing Alice Cooper's introduction of serpents on stage. Dave also closely worked with the touring acts, making certain of their accommodations. He became friends with many of them and established long-term connections with some of them, including Eric Clapton. Dave was even married at the Grande in 1969 in a ceremony hosted by Russ Gibb (in top hat and tails) that featured the groom in full-face makeup.

CARL LUNDGREN

In late 1967, artist Carl Lundgren sought out Grande poster legend Gary Grimshaw at the Trans-Love headquarters on the corner of Warren Avenue and John C. Lodge Service Drive. In the hope that he might be able to get some graphic work, Carl brought along samples of his art to show Gary. Grimshaw liked what he saw and offered Carl the opportunity to do his first Grande piece, a Grande postcard for an October 29, 1967 Trans-Love Energies benefit show.

On the strength of this first postcard, Carl then created his first color poster for the Grande—"Vanessa," so named because it utilized an image of actor Vanessa Redgrave lifted from *Life* magazine. This work for the November 10–11, 1967 shows became one of Carl's most popular and collectible pieces. Lundgren carried on creating a large body of poster and postcard pieces for local rock promoters Russ Gibb and Mike Quatro. "I was living in Ann Arbor, I rented a whole house because I made so much money doing the postcards. Russ Gibb was very generous; he paid me a lot of money for those postcard designs. And I was working for Mike Quatro who's also doing a lot of promotion for bands at concerts all over the state. I was paid between $75 and $90 a piece for the artwork, and at the time that was a lot of money!"[45]

Lundgren and Grimshaw cooperated on at least one very large piece that went largely uncredited. Male patrons of the Grande may remember passing through an outer anteroom, or smoking room, to enter the men's bathroom. There, an ambitious, swirling, psychedelic Day-Glo mural pulsated on all the

walls. Illuminated with black lights, it created a cosmic gateway for young men seeking the facilities. "Because Russ wanted it done or Gary needed the money, we went crazy for a couple days with Judy Janis who was Gary's girlfriend at the time."

As time passed, Carl, in turn, also delegated some of the Grande postcard work to other artists, including Donnie "Dope" Forsythe, Jerry Younkins, Dave Baker, Bonnie Greene and Chris Morton. With Russ Gibb continually wanting to cut costs, Carl, Gary and the others worked cooperatively with Crown Printing to use innovative techniques for maximizing their shrinking art budget. The year 1969 saw the last of the Grande postcards printed by Joel Landy at Red Star Press.

Carl went on to a career illustrating science-fiction book covers in New York City for thirteen years. He continues to create fine art pieces, and his rock poster reissues are more popular than ever. Carl and his lovely wife, Michele Lundgren, still live in midtown Detroit and own cats.

TWO IF BY SEA '68

*If the British march
By land or sea from the town to-night,
Hang a lantern aloft in the belfry arch
Of the North Church tower as a signal light,
One, if by land, and two, if by sea;
And I on the opposite shore will be,
Ready to ride and spread the alarm
Through every Middlesex village and farm,
For the country folk to be up and to arm.*

*From "Paul Revere's Ride"
Henry Wadsworth Longfellow*

19
STRICTLY BUSINESS

DYNAMIC DUO

As the new year dawned, Gibb and Glantz were looking forward to another profitable year. Their operation had a head start over anything similar in the Midwest and many other parts of the country. The huge success of the Cream shows in the fall of '67 and the connection Russ made with Robert Stigwood were only the beginning. In 1968, the British acts were coming, and the two principals of the Grande Ballroom were operating under a de facto partnership. Russ was the promoter, talent wrangler, toastmaster and face of the ballroom. Gabe was the property owner and in-house attorney who kept behind the scenes. He was there to review the fine print on contracts, but he was also the person who ran downtown to get a court order to remove police barricades from the ballroom's front door. The Grande had become a "taboo" destination for some teens. The ballroom was the place they wanted to go to precisely because their parents forbade them to. However, the DPD was not comfortable with hordes of white teenagers coming into a predominantly black neighborhood to enjoy themselves. The cops were just one of the forces constantly working against the operators. "People don't realize how hard it is to keep this place open," Gabe once told his young ward Rick Lockhart. In 1969, Mario Puzo published a fictional bestseller about a mafia crime boss. Glantz was so powerful and connected in the city of Detroit that Lockhart and his inner circle similarly nicknamed him the Godfather "because he could make things happen in Detroit when others could not."

PREMIER TALENT

Frank Barsalona was a talent agent from New York who learned the ropes of the business working for one of the largest agencies in the country, General Artists Corporation. In 1964, the old guard at GAC, accustomed to booking stodgy old lounge singers and Broadway stars, did not want to be bothered with organizing a promotional tour for a new British pop vocal group. The job fell to the new kid Frank, who organized the entire Beatles U.S. tour and tours for the Rolling Stones and the Yardbirds thereafter. Realizing the profit potential in rock 'n' roll, Barsalona formed his own company, Premier Talent, to book rock acts from both sides of the Atlantic. By 1966, Frank had developed a network of young upstart promoters he could count on when booking tours into their venues. Barsalona worked with hotshot promoters such as Bill Graham in San Francisco and Don Law in Boston and, by 1967, had added one Russ Gibb in Detroit. Unattached to the big record companies, he was an innovator in generating artists' revenue outside of selling records. Paul Vitello of the *New York Times* profiled Barsalona's significance: "The tours he scheduled in that network, which proved hugely successful, provided his clients with freelance income (10 percent of which was his); functioned as a farm system for artists in need of seasoning; and established the basic landscape of the rock concert circuit as it now exists in the United States."[46]

Barsalona could count on his network to book emerging artists. Promoters could afford to absorb a loss with a new act at their venues. Frank pitched handsome rewards in the long term as an act's popularity grew. Allegedly, Premier Talent had organized crime connections, an observation supported by emcee Dave Miller and Russ Gibb himself. In 1967, Dave and Russ flew to New York to meet with Premier and see a showcase concert by the Who. Before the show, they met at Premier's offices in a large boardroom with Chas Chandler (of the Animals), whose presence seemed rather random but welcome, and Frank Barsalona. Comparing the agent and his ornate surroundings to a Martin Scorsese mob film, Miller recalled, "It was pretty cool, [Barsalona was a] heavy Italian dude. [It was like] I was in a part of Goodfellas!"[47] When asked about Premier Talent in 2016, Russ Gibb removed all doubt. "Oh yeah, that was the mob!" he confirmed.

20
TALENT

THE AMBOY DUKES

John Drake, vocals
Ted Nugent, guitar
Steve Farmer, guitar
Rick Lober, vocals, saxophone, keyboards
Bill White, bass
Dave Palmer, drums

Guitarist Ted Nugent grew up in Detroit's Rosedale Park on Warwick, not far from the Finly brothers Jon and Steve. Ted and Jon Finly were in the school combo the Lourdes together. Playing R&B and Stones covers mostly at teen clubs, the Lourdes somehow got booked onto the package warming up the Supremes at Cobo Hall in 1964. After moving to Chicago with his family in 1965, Ted formed his first version of the Amboy Dukes. When Nugent returned to Detroit after high school in 1967, the new Detroit version of the Dukes recorded their eponymous debut disc on Mainstream Records for release that December.

At their January 19, 1968 premiere at the ballroom, the Dukes likely played a set containing tracks from their debut LP. A show was incomplete without "Baby Please Don't Go," a reimagining of the blues standard that charted for Belfast's "Them." Ted's flashy clothes and stage antics were also becoming a feature of the act. The group's second LP for mainstream,

Journey to the Center of the Mind, came out in April 1968. The historical record shows the Dukes playing at the Grande only five times that year despite the success of these recordings. The single peaked at number 16 on the Billboard top 100 chart in August. Ted Nugent went on to a platinum-selling solo career in the mid-'70s.

THE PSYCHEDELIC STOOGES

Iggy Stooge (Pop), vocals
Ron Asheton, guitar
Dave Alexander, bass
Scott Asheton, drums

After leaving the Prime Movers in the fall of 1966, Jim Osterberg (Iggy Stooge/Pop) had moved to Chicago to dig deeper into the blues with

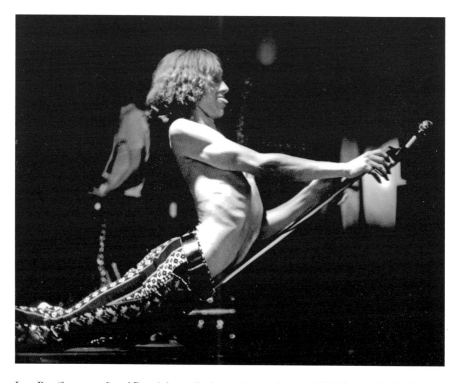

Iggy Pop (foreground) and Ron Asheton (in the background), circa 1968. *Courtesy Leni Sinclair.*

drummer Sam Lay of the Paul Butterfield Blues Band. Returning to Ann Arbor in late '67, Iggy rang up the Asheton brothers and began working on an act with original material. Taking their cues from the droning sounds of Detroit industry, the Stooges sought to create a sonic analog of the gritty, hard-core, day-to-day blue-collar experience. Jeep Holland put them on starting in January 1968. Iggy Stooge trod the stage at the Grande early on in whiteface and tinfoil suits or wigs that shredded away, leaving little to the imagination. The group applied contact microphones to household appliances and two-hundred-gallon fuel oil drums to create cacophonous effects. Ron Asheton told author Joe Ambrose in *Gimme Danger*: "People didn't know what to think about us. We had our own instruments. For example we poured water in a blender and put a mike on top of it. We got this really weird bubbling water sound which we put through the PA. Iggy would dance on a washboard with his golf shoes!"

Iggy Stooge allegedly patented the audience invasion and stage dive at the Grande Ballroom. Spectacle is what Russ Gibb wanted, and innovation is what he appreciated. Audiences had short memories, and they fed on novelty as much as talent. The promotional artifacts for the Grande Ballroom indicate that the Stooges were popular enough to perform there some two dozen times in 1968. Considered by many to be the first proto-punk band, the Stooges released their first LP for Elektra Records in 1969. Ultimately, Iggy Pop became one of the most commercially successful artists ever to come out of the Grande.

THE FROST

Dick Wagner, lead guitar, vocal
Donny Hartman, guitar, vocals, harmonica
Gordy Garris, bass, vocals
Bobby Rigg, drums, vocals

After departing from the Bossmen, guitarist Dick Wagner had a chance to audition for the front-man spot with Blood, Sweat and Tears. When this opportunity did not pan out, Wagner returned to Michigan to form a new group. First billed as Dick Wagner and the Frosts, a new definitive lineup first appeared at the Grande in February 1968. Dick had just added bassist Gordy Garris and shortened the group's name to the Frost. The men signed

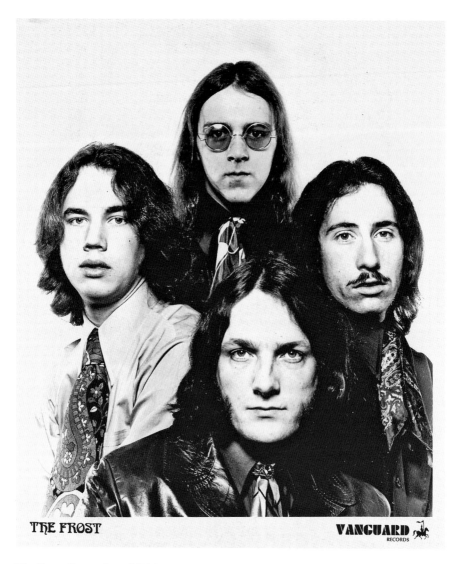

The Frost. *Courtesy Susan Michelson.*

to Jeep Holland's A2 Productions, which automatically plugged them into the Grande Ballroom calendar. Dick Wagner remembered Jeep Holland as being a productive but flawed individual.

> *He was doing a lot of methamphetamines, so he was very high and then he would crash for about two or three days and you couldn't get a hold of him, no matter what. He was just dead to the world until he resurfaced. He was*

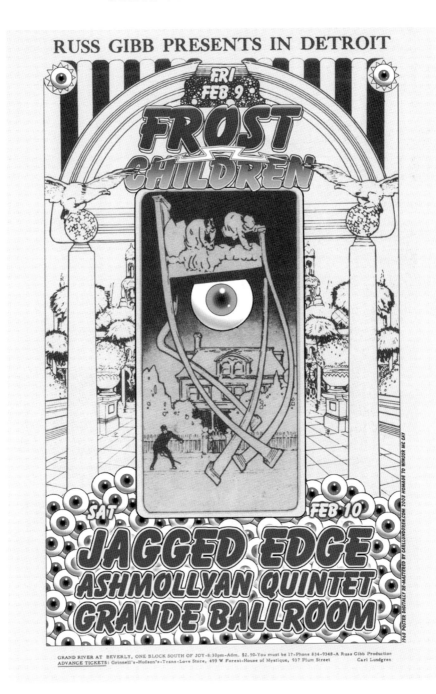

The Frost and Jagged Edge, February 1968. *Art by Carl Lundgren.*

quite a character that way. He also drove that blue van that he had at the highest speeds that anyone has ever achieved on the highway, he did some dangerous driving, absolutely incredible! But he was a good guy Jeep, his heart was in the right place.[48]

Starting in February, the Frost played at the Grande at least a dozen times in 1968, quickly becoming fan favorites. Dick recalled, "We were at the Grande a lot because we were very successful there. It was always sold out. Craziness. Kids running up the stage, 'Beatlesque' in a sense. We had to have our road crew standing there to make sure a kid didn't come up on stage with us, so it was kind of wild."[49]

This popularity brought them to the attention of Vanguard Records scouts who had started trawling the Detroit scene for acts to sign. Vanguard executives wined and dined the band for weeks trying to win the members over. Released in 1969, their first Vanguard LP, *Frost Music*, sold fifty thousand copies in two weeks. Their next effort, *Rock 'n' Roll Music*, captured at the Grande in '68, was to be an entire album of live material. Vanguard oddly elected to fill half the released version with studio tracks. The title cut became a Grande and Motor City anthem. Vanguard ultimately failed to break the band nationally, and the band folded in 1970 after three albums with the record company. Dick Wagner went on to a very successful career as a composer and guitarist with Alice Cooper, Lou Reed, David Bowie and Ursa Major.

BIG BROTHER AND THE HOLDING COMPANY

Janis Joplin and Big Brother and the Holding Company flew into Detroit at the end of a short East Coast–Midwest tour on March 1, 1968. The band was in demand after its successful June 1967 appearance at the Monterey Pop Festival. It now owed Columbia Records a second album, which it planned to record live over two nights at the Grande. When the group launched into its first song that evening, someone in the crew went straight for the strobe light switch, immediately blasting Janis with the megawatt psychedelic novelty effect. Russ Gibb remembered, "Suddenly she jumped right off the stage and ran directly into my office and shouted, 'Shut that fucking thing off!'"[50] With the band still playing, Russ had the light switched off, and Janis resumed the set as if nothing had happened.

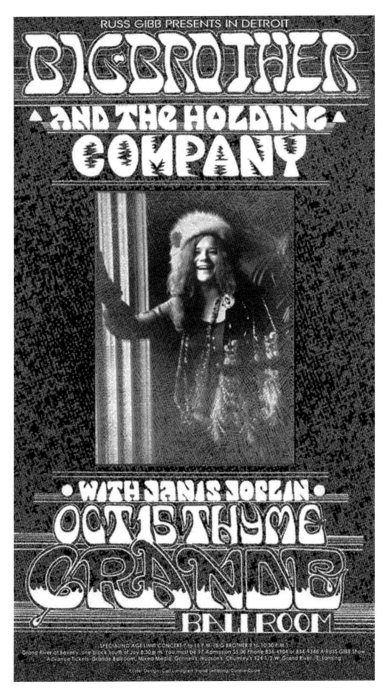

Big Brother and the Holding Company, October 1968. *Art by Carl Lundgren.*

The songs captured at the Grande unfortunately did not meet producer John Simons's standard requirements. The group immediately went into the studio in New York after its engagement in Detroit was completed. Originally to be titled "Sex, Dope and Cheap Thrills," the final product *Cheap Thrills* was released on August 12 1968. It reached number one on the Billboard charts and was there for eight nonconsecutive weeks. It became the most successful album of 1968, selling over one million copies.

On October 15, 1968, Big Brother returned to the Grande Ballroom for a Tuesday night engagement. On that very day, *Cheap Thrills* received a gold record by the RIAA. Janis Joplin split from Big Brother at the end of 1968.

Fleetwood Mac, Pink Floyd and the Who

In July, Russ Gibb and Tom Wright put together one of the most impressive triple headliner sequences Detroit audiences have ever witnessed. Since its second stint at the venue in June, the Who had continued to sing the Grande's praises in the United Kingdom. The word was out that *the* tour stop to hit in the Midwest was Detroit's Grande Ballroom.

Fleetwood Mac, July 11, $2.50

Peter Green, vocals, guitar, harmonica
Jeremy Spencer, vocals, slide guitar, piano
John McVie, bass guitar
Mick Fleetwood, drums

Fleetwood Mac was a group of musicians that had spun off from John Mayall's Bluesbreakers. Steeped in the blues and at one time featuring the twin guitar stylings of Peter Green and Jeremy Spencer, the group's debut album, released in February 1968, had done well in the United Kingdom, and the band was looking to develop its following in the United States. Per the promotional materials, this was an all-ages show.

One of Jeep's groups from Kalamazoo, the Thyme, was the supporting act for Thursday and Friday.

Pink Floyd, July 12, $3.50

This was Pink Floyd's second and last appearance at the Grande, having previously appeared with the Who back in June. Its second Capitol LP, *A Saucer full of Secrets*, had introduced new guitarist David Gilmour, who was also along on this date. The band's set at this time always included the ominous "Set the Controls for the Heart of the Sun," which featured Nick Mason playing his drum kit with timpani mallets. Pink Floyd's next visit to Michigan was as a headliner at the Oakland University Pop Rock festival on September 1, 1968.

The Who, July 13, $4.50

The Who's third appearance at the Grande warranted scheduling two shows, one at 6:00 p.m. and one at 10:00 p.m. The Who's popularity was so great that Gibb could charge $4.50 a head and still sell more than capacity, though some did complain at this exorbitant price. The Ballroom was often too small for certain acts. Starting with the Jefferson Airplane at Ford Auditorium in 1967, Gibb and Glantz continually looked for opportunities to book larger shows in larger venues in Detroit, Cleveland, Toronto and beyond.

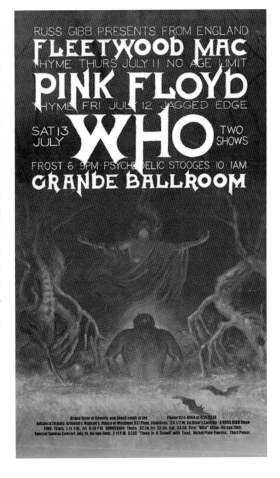

The Who, Pink Floyd and Fleetwood Mac, July 1968. *Art by Carl Lundgren.*

THIRD POWER

Jem Targal, bass, vocals
Drew Abbott, guitar, vocals
Jim Craig, drums

Not many Grande bands can claim that they first met at a missile launch site. However, Farmington Hills' Third Power did precisely that. Bassist Jem Targal first met a drummer named Drew Abbott in the speed-reading lab at Oakland Community College–Auburn Hills. In 1965, this OCC campus began conducting classes at a repurposed Nike missile defense installation. Abbott,

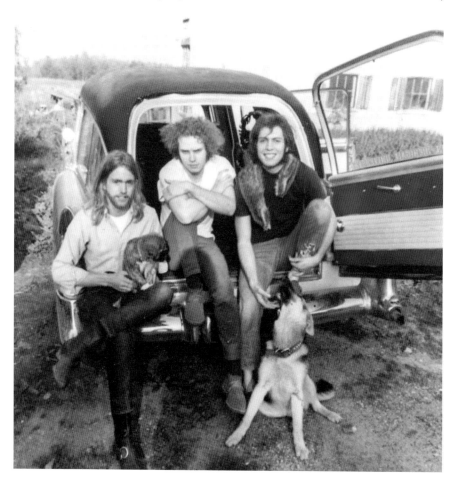

Third Power and a hearse, circa 1969. *From left to right:* Jim Craig, Drew Abbott and Jem Targal. *Courtesy Tom Wright.*

after switching to guitar, joined with bassist Targal and drummer Jim Craig to form a trio with the goal of playing the teen clubs and other dances.

With the unusual moniker of the Bluesies, the group soon progressed by adding original material. Vocalist and bassist Targal was a classically trained violinist who, as a composer, proved to be very prolific. With a new name, Third Power, the act began absorbing the sounds coming from the West Coast and England in late 1966. At about the same time, the three members first visited the Grande Ballroom. The venue soon became their ideal location as they polished their act throughout the state of Michigan. Jem Targal remarked, "Our whole goal was to play there."[51]

Aspiring to what Eric Clapton and the Cream were doing, the group sought to rise above the competition by having some of the loudest sound reinforcement possible. Most venues had little, if any, sound gear, and bands suffered. "You were at the mercy of the PA system," Jem laughed.[52] Third Power constructed its own wooden speaker cabinets that were so durable and heavy they called him their "flight cabinets"—meaning they could be dropped from an airplane and still survive. High-wattage amplifiers from Heathkit and Floyd James completed the systems.

In 1968, represented by A2 Productions and Jeep Holland, the group was ready for its debut at the Grande on July 14. The band members' skills, polished by playing many small club dates, combined with their superior equipment, quickly made them a popular opening act. Over the next nine months, Third Power honed their original material before large Grande audiences. The group paid its dues on bills that included heavy groups like John Mayall, the Who and Procol Harum. Bob Seger never booked a gig at the Grande, but he sat in with the trio from time to time. While speaking on a WCSX live call-in show, Seger recalled, "I used to go to Drew's house and just sit and listen to him play and then jump in and say 'Can I jam with ya?' I just loved the way he played guitar and the way Jem played bass and I just loved that group, and of course that's how we came to hook up to play for many years together."[53]

Seger later tapped Drew Abbott as the guitarist for his million-selling *Silver Bullet* backing band. Thanks to the band's hard work, when the record companies came calling, Third Power was ready. At the Michigan Rock 'n' Roll Revival show at the state fairgrounds in May 1969, Venture Records president Sam Charter bagged both the Frost and Third Power. After a couple of two-week sessions at Venture studios in New York City, the band released its LP *Believe* in 1970.

THE MC5 VERSUS CREAM

In October 1967, the MC5 had opened for the first big British group to play at the Grande, Cream. There was a degree of tension that weekend between the two acts, fueled by the pay disparity between them. The MC5 never earned more than $125 per night, whereas Cream commanded four figures for each show. The local group's manager John Sinclair recalled that things did not go well at the Grande that fall weekend:

We opened up for Cream on their first tour, and they were already huge in their own minds. And we came in to set up and their roadies had Ginger Baker's drums covering the entire middle of the stage. And they said, "Well mates you'll have to set up around this." Now this is our "home," and we had to put our drums on one side, Tyner on the other side. It was humiliating; we were just humiliated! I never experienced anything like that with these punks. We didn't think they were so great. They made a nice record, but they were just three guys. We could kick their ass—there's five of us! That's the way that we thought, you know? So, man, when we

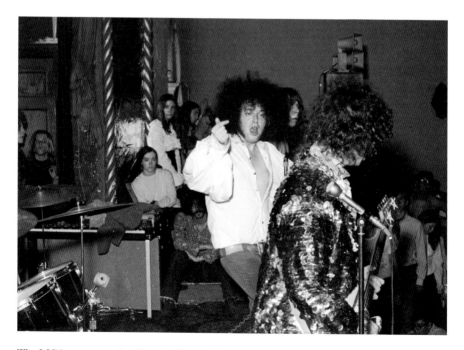

The MC5 onstage at the Grande: Wayne Kramer (guitar), Rob Tyner and Fred Smith. *Courtesy Leni Sinclair.*

got a chance to open for them again…they [MC5] *put that show together probably over a period of about a month.*[54]

Once again, the MC5 were the openers for Cream during a three-day run at the venue starting on June 7, 1968. That Friday was the hottest day of the week in Detroit, with the thermometer topping 91 degrees. Unlike the decades past, when the venue shut down in the summer months, the Grande that evening ushered in beyond-capacity crowds that some say surpassed two thousand young people. The facility was like a convection oven with only five or so twenty-four-inch drum fans to vent hot air up and out of the roof. When people started passing out, management organized a bucket brigade and began dousing the crowd with water.

John Sinclair recalled what it was like the night the air was so heavy perspiration dripped from the walls:

It was about 105 degrees in the Grande, and it was packed from wall to wall. It was not air-conditioned. It was hotter than the hedges of hell in there, man! It was so hot that you couldn't see straight! When you get a show like that, I mean, Russ and Gabe Glantz, they would way oversell that stuff. Everybody, Bill Graham, that's how he made his millions on the tickets that he didn't turn in, you know, to pay the band with….Yeah, so they had a legal capacity, so they would never "sell" more than that number of tickets. They would sell 'em until people stopped coming! So for the Cream or the Who, you know the promenades? People would be sitting all along the floor, everything totally packed. Well, we killed the Cream. They [the MC5] *played this show that was just so incredible. The people were just, just rubble at the end of the night. And then the Cream had to come on. Of course, they were…brought there in their limo after our show was over. They couldn't figure why they couldn't get anything going with this crowd. Finally, someone told 'em, "The opening band blew you away, my man!" That was one of the most satisfying moments I ever had when we killed 'em! I just believed in the MC5 so much, and I just felt that they could really "kill" anybody that they came up against. In the sense of playing better, "kill." In the sense of playing better and getting a bigger crowd response, in the positive sense you know?*[55]

BLUESBREAKER

The "Godfather of British Blues," John Mayall, and his Bluesbreakers had been booked for a three-day run at the Grande starting on October 11, 1968. Mayall had been mentor and bandleader to a number of young British guitar upstarts. These had included Eric Clapton, Peter Green (Fleetwood Mac) and his most recent hire, nineteen-year-old Mick Taylor.

Clapton and British super group Cream were in the middle of their farewell tour, a nineteen-venue, month-long concert sequence with a stop in Detroit on October 12. The band's career had skyrocketed to dizzying heights since its first appearance at the Grande one year prior. It was so successful that the BBC reported in 1968 that the group had earned more than the "entire British government's subsidy to the arts." The band's July 1968 Polydor release *Wheels of Fire* was the world's first double LP ever to go platinum. Cream virtually filled the fifteen-thousand-seat Olympia Stadium that Saturday. The group's unprecedented popularity raised its Detroit guarantee to $22,000, plus 60 percent of the gross over $40,000. Potential profits and attendance were roughly ten times what the Grande's 1,500-person capacity could offer.

At the Grande that Saturday night, the local trio Third Power had thoroughly warmed up the audience, and by midnight, Mayall and his group were well into their set. Unlike the previous evening, there was a buzz building in the audience that night. Grande regulars and cognoscenti were aware that Cream and Clapton were playing at the Old Red Barn just down Grand River. At three dollars a ticket, John Mayall was a less expensive option, and some speculated about what might occur, considering the proximity of the two concerts. Just as Saturday turned into Sunday, some noticed Russ Gibb and a companion standing at the top of the stage stairs to the right of the audience. Edging forward from beside the Altec-Lansing speakers, Russ's guest began to talk to Mayall as he played. The audience began stirring, and some rose to their feet. What they saw was the twenty-four-year-old guitarist from Cream asking permission to sit in with his old mates. Rick Patrny recalled, "I recognized Clapton. I jumped up and started poking the people around me, saying, 'Look it's Clapton; it's Clapton.' A number of people told me to shut up and sit down."[56]

As the music paused, twenty-four-year-old Eric Clapton took the stage for the last time at the Grande. Mick Taylor, falling to his knees, handed Clapton his prized Gibson Les Paul and began to kowtow to the prodigal

Bluesbreaker. Patrny recalls that by this point anyone who had dozed off during John Mayall's set had awoken: "By this time, everyone was on their feet clapping and cheering. I don't remember what they played other than that the first piece they played ran on for about forty-five minutes. I believe they played one other tune for a few minutes, and then Clapton exited off the stage as magically as he came in. We all stood there awestruck."[57]

Touring America and playing ballrooms just like the Grande allowed Cream to build its American fan base. Clapton's encore that night at the Grande, although likely orchestrated by Russ Gibb, was perhaps both a thank-you and a validation of the building's role in Cream's success. The group played its final concerts together at London's Royal Albert Hall on November 25–26, 1968.

THE BLUES

In the 1960s, traditional blues artists were having difficulty selling records and getting work in African American venues. Young blacks were more apt to support and purchase records from soul singers of this period. Acts like Sam and Dave, Otis Redding or the Temptations were the ones profiting from this preference. Considered passé, the older blues artists like John Lee Hooker or Muddy Waters saw their fortunes fading. However, thanks to British acts like the Rolling Stones, Cream and John Mayall, white American kids were learning about the blues. Promoters in the new American network of ballrooms began booking blues artists on the bill with established rock acts. Both Bill Graham and Russ Gibb had eclectic tastes rooted in R&B and jazz. They both made certain to feature these artists regularly. At the Grande, you could catch all of the legendary blues artists of the day, like Albert King, B.B. King, Howlin' Wolf, John Lee Hooker, James Cotton and Buddy Guy. On any given night, one might also be able to catch some of the new guard of blues talent like the Paul Butterfield Blues Band, the Steve Miller blues band, Taj Mahal or Canned Heat. All of these acts, along with their young British blues counterparts, made for some eclectic lineups at the Grande.

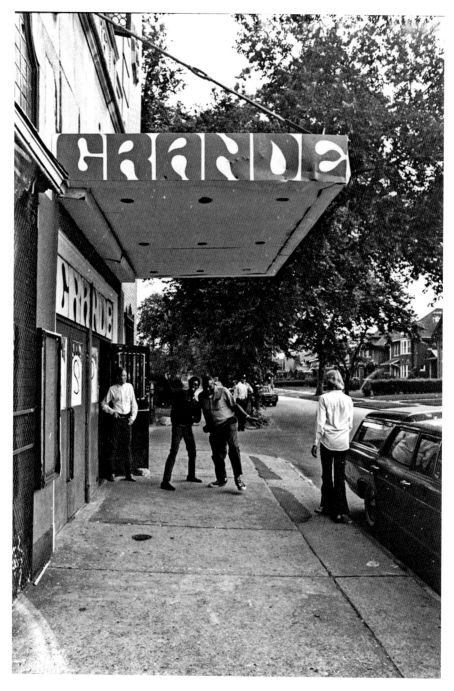

Howlin' Wolf arrives at the Grande. *From left to right*: Bill Robbins, unidentified fan, Howlin' Wolf and A.J. Laterell. *Courtesy Tom Wright.*

THE JEFF BECK GROUP

Jeff Beck, guitar
Ron Wood (Pre-Faces and Rolling Stones), bass
Mickey Waller, drums
Rod Stewart (Pre-Faces), vocals
Tony Newman, drums (1969 tour)
Nicky Hopkins, piano (1969 tour)

One of the most significant British groups to play the Grande Ballroom was the Jeff Beck group. Formed in 1967, the group went through a series of drummers before settling on a consistent four-piece lineup. The group's first U.S. tour, booked by its New York agent, Frank Barsalona, included two nights at the Grande, July 5 and 6, 1968. As with his other British groups, Barsalona plugged the JBG into his ballroom network to grow its American audience. For this initial outing, the group was road-testing material for its first album, *Truth*, to be released the following month. The group returned again in November for three nights, further reinforcing its popularity with Detroit audiences.

The group came back to the Grande Ballroom twice in 1969, this time with the addition of the great Nicky Hopkins on piano. In bootleg recordings from this year, listeners can hear Hopkins's soulful, blues-influenced style as played on the Grande's house upright piano. Hopkins was a sought-after London session player who also worked with the Kinks, the Who and the Rolling Stones.

In June 1969, the Jeff Beck Group released *Beck-ola*. The group's short U.S. summer tour, plagued by infighting, made their July 26 date at the Grande Ballroom their last in the United States, ever. The band had been booked to play Woodstock (August 15–17) but disbanded virtually on the eve of the festival. Nicky Hopkins, however, did perform at the event, appearing with Jefferson Airplane. Russ Gibb always enjoyed having the Jeff Beck Group on at the Grande. His recollections were in keeping with the general audience sentiment:

> *Now, remember as one gets older, one's memory starts to get a wee bit hazy. Jeff Beck, I believe I booked them via Premier Talent out of New York. As for Jeff working for me, he was a little older than most of the groups I booked, Therefore, he was more biz like in his dealings. Jeff always did the job he was paid to do, performance-wise. He gave his all. His fans loved him, and he never disappointed them. In my opinion, Jeff Beck was a real professional entertainer. Plus, he always packed the Grande.*[58]

Typical 1968 Set List

"Shapes of Things to Come"
"You Shook Me—Let Me Love You"
"Blues De Luxe"
"Jeff's Boogie"
"Rock My Plimsoul"
"A Natural Woman"
"Rice Pudding"
"Sweet Little Angel"
"I Ain't Superstitious"

Typical 1969 Set List

"Shapes of Things"
"You Shook Me"
"Let Me Love You"
"Nicky's Blues"
"Jeff's Boogie"
"Rock My Plimsoul"
"Natural Woman"
"Rice Pudding"
"Black Angel Blues"
"I Ain't Superstitious"
"Stone Crazy"
"Talk to Me Baby"
"I Believe I'll Dust My Broom"

RUTH HOFFMAN

Ruth Hoffman was one of those suburban kids who ventured into Detroit for the ballroom experience and became dedicated regulars. Ruth frequented the Grande so much that she rented an apartment nearby. She recalled, "It just opened that whole thing up and got me into the city…that dirty, wonderful, part of the city."[59] Ruth endeared herself to the Grande staff in addition to connecting with both local and touring musicians. She experienced

both fleeting and enduring relationships with some of the most supremely talented artists of the era. For example, she became close to California blues-rockers Canned Heat, and she absorbed their energy.

> *Sometimes I would get so caught up in the music that...I was absolutely transported. I remember one night, Canned Heat was playing and I was into it, and I was doing this* [rocks forward and pounds leg with fist] *and doing it. I was beating my leg until I had a bruise about this big on my leg. I'd just beaten myself to a bruise, but I was so into it and it just, like kept me going you know? Leaving the Grande with music kind of ringing in my ears. I remember going to bed a couple of times with still this throbbing going on and being just sort of falling into this wonderful sleep that was still involved in the music. It's hard to really capture how, how it was part of everything. It was part of your whole being at times.*[60]

Ruth regularly took photographs of Grande performers with her little Kodak Instamatic camera. The fast-fading color prints record a time and place that helped shape her life. This was true not solely for Ruth; the ballroom was fast becoming a significant place in many young people's lives.

> *How sad it would be if the Grande never existed. I would have found, I'm sure, another way to, become who I am, I think, but I can't quite figure out what that might have been because the Grande was the place that so many parts of me were able to be expressed. My interest in music, my interest in the world, my interest in other beings, in other ways of looking at the world. Again, growing up where I grew up, I knew instinctively that what I was, what I was living in, in the suburbs wasn't right. I knew there were other things happening. If you didn't know how to get there, the Grande gave me that vehicle to get there, to find out about that.*[61]

PETE AND TOM

TOM WRIGHT

Road Manager, Rock Photographer

Born in Birmingham, Alabama, Tom Wright's first exposure to rock 'n' roll was seeing the "First Lady of Rockabilly" Wanda Jackson at the magnificently ornate Alabama Theater in downtown Birmingham. A pair of architects named Graven and Mayger who operated out of Chicago and Detroit back in the '20s designed the Alabama. Experiencing such raucous music in such a beautiful and cavernous space had a distinct impression on young Tom, and perhaps a prescient one.

In 1962, Tom's stepfather accepted an assignment to a military base in England. Young Tom followed, "under protest," and enrolled at the Ealing Art School in a western

Tom Wright. *Courtesy Tom Wright.*

borough of London. His school friendship with flat mate Pete Townsend led to work in 1967 and '68 as the Who's photographer and road manager on their first tours of America. Tom's later work with acts such as the Faces, the Eagles and the James Gang produced an incredible rock photography portfolio.

THE WHO

Russ Gibb told the *Detroit Free Press* in 1986 that he "first saw the English superstar band playing at a Chatham Ontario church basement," though promotional materials from the time could not be found to confirm this event. What is known is that Premier Talent contracted the act for a stop at the Grande on the first of two 1968 U.S. tours. Dave Miller does remember meeting the group's American road manager, Tom Wright, in NYC prior to the start of these headliner visits.

After hitting nearly fifty cities in nearly fifty-nine days, the band had yet to garner a proper significant level of response and recognition from an

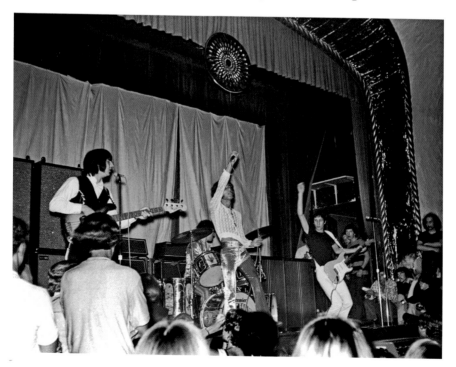

The Who at the Grande Ballroom, 1968. *Courtesy Tom Weschler.*

audience. Wright's book *Roadwork* contains an excellent account of the road-weary group's introduction to the Grande Ballroom on March 9, 1968. Wright wrote:

> *The band looked at each other. This was the audience they worked their whole lives to find, and halfway into the first song they knew it for sure. The entire building seemed to work with them. The crowd, stoned out of their minds, was watching, approving everything the band did. It was as if this whole tour had been a long, agonizing footrace to this, the last lap, with no one behind them. The guys got their second wind from the roar of the crowd and went full blast. For The Who, it was the perfect set. The next day they would sell a zillion records in Detroit, disc jockeys raving. The Who had finally arrived in America, moments before they were ready to leave and never come back. They never topped that show.*

Tom Wright and the band maintain to this day that this positive experience motivated them to continue and not pack it all in. The Grande, crowded beyond its 1,500-person capacity, was a catalyst for their careers. Fire marshal be damned, probably more than 2,000 people saw the Who that night. If you didn't, here is a typical set list for that period:

"Substitute"
"I Can't Explain"
"Heaven and Hell"
"Fortune Teller"
"Tattoo"
"Summertime Blues"
"Young Man Blues"
"Boris the Spider"
"Relax"
"A Quick One, While He's Away"
"Happy Jack"
"I'm a Boy"
"Magic Bus"
"Shakin' All Over"
"My Generation"

DIRECTEUR DE LA GRANDE

A few days after the completion of the Who's spring headliner tour, Tom Wright landed in New York for a job in magazine publishing. He gushed about the fabulous Detroit music scene at the Grande to his publisher enough that he received an assignment to do a photo essay on what was happening in the Motor City. Tom spent some time shooting and interviewing musicians around town before he returned to New York, film canisters in hand. There he found his new employer's offices padlocked and the magazine out of business. With his planned exposé of the Detroit sound aborted, he knew what to do. A phone call to Russ Gibb in Detroit resulted in a job managing the Grande Ballroom. Tom was handy and possessed some carpenter skills, so he set about knocking the ballroom into better shape.

> *After four or five months, I had three or four guys living there; we built a loft over what used to be the coat check. And then we revived the coat check and made that into a profit thing. Then we started restoring the building, which was a total joy. That was our mission; the shows were just our reward for working all week.*
>
> *It was painted a bunch of weird colors; we painted the whole thing in one color, which was a kind of sandy beige, the color of beach sand really. And at that point, the architecture just leaped out, and what was left of the stained-glass windows offset that. We were just stunned at how beautiful it was.*[62]

Tom and his team also brought in recycled auto show carpeting. It dropped in nice and flush on the promenade bordering the dance floor. With the ballroom operating in the black, he pressed Russ Gibb to reinvest a little of the profits to improve the look and functionality of the venue. In making these improvements, Tom's respect for the architect Charles Agree and his marvelous accomplishment grew.

> *I'm sure acoustics was a part of the design scenario, but the Grande Ballroom was like an antique Gibson guitar that is just like, perfect, you know, you hit the one note, and it rings for like four minutes without distortion. And there was no echo in the Grande—there was just presence—and that sounds like a small thing, but to a band, and this was the days before monitors…bands couldn't hear what they were doing other than what they heard from the building. And you know, in the case of the Who, they just, they would just give up, after the first note at most places and just saying, "To hell with it, I can't hear anything, you can't hear anything and we don't know if our audience can hear anything,*

and whatever we say comes back to us in thirty seconds after it bounces off a bunch of walls and stuff," you know? But at the Grande, you could have a full house of people and the PA, let's say, would go out—this never happened, but just to tell you how good the sound was—one person standing on the stage could talk to the whole room full of people without amplification and everybody would hear every word. Now that's just, that's not by accident. Whoever designed that either had beginner's luck or did the right research or put themselves in a situation because when they built that they weren't thinking about amplifiers. They were thinking about, you know, bands, people playing trumpets and all that. Anyway the acoustics were just perfect and so as soon as any given band, I mean, Chuck Berry or Joe Cocker, anybody I can think of...by the end of sound check, they were just—they were different people. And then when that audience came in it was just ready to go and knew most of the material that these people were playing they were right there with them.[63]

Wright brought many efficiencies to the day-to-day operation of the Grande and things ran better with a full-time manager. In addition, Wright's discerning musical taste recommended many great acts well beyond his British connections.

GHOSTS OF THE GRANDE

Beginning in 1966, some folks who spent the quiet off hours in the Grande Ballroom reported hearing and seeing things out of the ordinary. An image in a restroom mirror, the disembodied sound of a horn, a door or window mysteriously slamming shut were all examples of unexplained phenomena. A few performers and employees began to think that the forty-year-old structure was haunted. Some paranormal explorers believe that ghosts and spirits are persons wandering the afterlife having experienced a sudden or tragic death. It is up to the reader to speculate if this pair of events from the Grande's history are connected.

Geneva Ulman was shot to death on the Grande dance floor in 1932 (see page 58). Trombonist Bruno Jaworski, a regular Grande musician, died in the Edgewater Park Dance Pavilion fire of 1954 (see page 68). Mourners assembled at St. Valentine's Church for his funeral on October 7, 1954. Russ Gibb reopened the doors to the Grande precisely twelve years later, on October 7, 1966.

22
KICK OUT THE JAMS

In September 1968, Elektra Records PR man Danny Fields visited Detroit and Ann Arbor at the recommendation of Bob Rudnick and Dennis Frawley from WFMU, New Jersey. Impressed after having seen the MC5 and the Psychedelic Stooges perform, Fields excitedly recommended them to Elektra president Jack Holzman over the phone. Holzman signed both the MC5 and the Stooges to the label, and plans were soon in the works to record the MC5's first album, *Kick Out the Jams*, in October, live at the Grande. The name of the LP came from the taunts the band lobbed from the wings at poorly prepared bands struggling on the Grande stage. "Get down or get out!"—put on a good show or go home—was their message.

The goal was to preserve the high energy of the band's own live show on vinyl. Wayne Kramer told *Mix Magazine*,

> *The conventional wisdom was, you cut two or three studio albums and then you did your live album. We thought it was a revolutionary move to do the first album live. We had worked so hard to perfect our live performance, and I think that the consensus was that The MC5 is all about the live performance, so let's see if we can capture this. Our whole thing was based on James Brown. We listened to* Live at the Apollo *endlessly on acid. We would listen to that in the van in the early days of 8-tracks on the way to the gigs to get us up for the gig. If you played in a band in Detroit in the days before The MC5, everybody did "Please, Please, Please" and "I'll Go Crazy." These were standards. We modeled The MC5's performance*

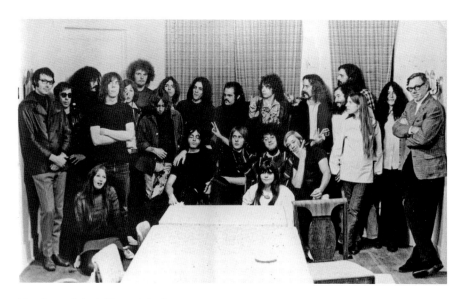

Members of the MC5 and the Psychedelic Stooges at the Elektra records signing, September 1968. Danny Fields (second from left) and Jack Holzman, Elektra president (far right), are pictured here. *Courtesy Leni Sinclair.*

on those records. Everything we did was on a gut level about sweat and energy. It was anti-refinement. That's what we were consciously going for.

Oak Park native, record producer and Grande fan Don Was reflected on the elements of the Grande scene in general and of the MC5's sound in particular:

Well, one thing about the music that you heard down there, it was very raw; MC5, you know, probably the best example; the Stooges, the same thing. But as raw as it was, it always hit a groove. It wasn't like other, other metal stuff of which there wasn't any at the time [laughs], okay? This was the start of it, but a lot of people will pick up on the distorted sound and started playing a lot of notes, but forgot about the groove. This stuff was always funky, always had an R&B undertone, number one, and number two, it was, it was always about the feel and not about the technique—not about the perfection of the delivery. It was always, always raw, but it always felt good. And if you just remembered those two things, always keep a groove under there and make sure the thing feels good, you're never going to go too far astray. If you listen to most crappy music it's because someone's forgotten one of those two elements.[64]

The MC5 had tapped into a primal source of energy and spent years rehearsing and refining its act. Band members adopted a method of continuous improvement, constantly readjusting for what worked and discarding what did not. Manager John Sinclair corroborates this strategy and how the MC5 channeled the energy, groove and polish of James Brown:

> The MC5 man, we'd train. It was like boxing, you know. We'd train. All week they'd rehearse. Tyner, he'd study our show and then say, "Well, here we need something that goes like this to take it to there." Then Tyner and Wayne and Fred, they would get together, and they'd work out the tune. Then they'd polish it and practice it [and] then put it in a spot in the set, so your set that week was much improved over the last week, do you know what I mean? So it was really thrilling; it was a creative process that was just brilliant and you got instant results. Because you went up Friday or Saturday night the next week against Sly and the Family Stone or the Who! We used to laugh about it on the way to gigs; we would set our "dials" on "Total Destroy"! [Laughs] That was our mindset! We'd smoke about fifty joints on the way to gig, and we'd be playing James Brown Live at the Apollo on our sound system cranked all the way up. Yeah, you'd pull up to the gig and open up the doors to the van, and it'd be like a bunch of Dobermans running after some meat! They couldn't wait to get on stage, you know, and kick 'em out! Oh! It was so much fun; there is just no way to describe it. There's nothing like that in today's world, really. That was so thrilling. And it was all wholesome.[65]

Elektra parked their mobile recording truck in the alley in order to run all their cables up to the second-floor stage The MC5 recorded packed shows on the evenings of October 30 and Halloween 1968. They also recorded the same set on the thirty-first during the day with no audience. Martha Kinsell of the *Free Press* wrote:

> The pop event of the year was last week. Even people normally anti-MC5 could only gasp, "outa-sight." The occasion was Elektra records second of two days and nights of recording Detroit's bad boys of acid rock for their first album. Even company president Jack Holzman, a hip, Eugene McCarthy–sized man, was here. The show was presided over by engineer Bruce Botnick who conducted an orchestra of $100,000 worth of equipment including a tiny temperamental TV monitor which kept him tuned to stage happenings.

It was free admission to guarantee packed houses, and the MC5 faithful showed up in droves. Brother J.C. Crawford, the MC5's master of ceremonies, wound the crowd up.

Brothers and Sisters
I wanna see a sea of hands out there.
Let me see a sea of hands.
I want everybody to kick up some noise.
I wanna hear some revolution out there, brothers
I wanna hear a little revolution.
Brothers and sisters, the time has come
For each and every one of you to decide
Whether you are gonna be the problem,
Or whether you are gonna be the solution.
You must choose, brothers, you must choose.
It takes 5 seconds, 5 seconds of decision.
5 seconds to realize your purpose here on the planet.
It takes 5 seconds to realize that it's time to move.

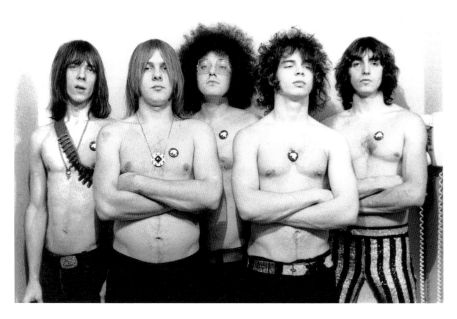

An MC5 staged publicity photo at 1510 Hill Street, Ann Arbor, Michigan, 1968. *Courtesy Leni Sinclair.*

It's time to get down with it.
Brothers, it's time to testify and I want to know,
Are you ready to testify?
Are you ready?
I Give You a Testimonial, the MC5!

From the LP Kick Out the Jams, *MC5, copyright 1969, Elektra Records*

Engineers Botnick and Wally Heider captured the multiple shows on eight-track tape for mix down in Los Angeles in November. Elektra released *Kick Out the Jams* in February 1969.

Michael Davis also told Rick Clark of *Mix Magazine*:

> *There was this feeling of electricity in the air when we played. Especially on "Kick out the Jams," I felt like I was floating above the ground. There was so much energy present and people picking up on it, and we were just laying it out there. I felt like I was tied to a white rope of electricity and just shaking on it, and everybody was just there, a part of the light. It was magic.*[66]

Part VIII

GREEDHEAD OPERA '69

There is more in you of good than you know, child of the kindly West. Some courage and some wisdom, blended in measure. If more of us valued food and cheer and song above hoarded gold, it would be a merrier world.
—*J.R.R. Tolkien,* The Hobbit

In 1968, the Grande Ballroom had made a lot of money. With the profits, the partners went farther afield, producing shows in other cities, including even a "Grande Cleveland" for a time. Gibb and Glantz had been nicknamed "Greedheads," a moniker that Gibb, for one, did not dismiss. In fact, he often used it in referring to himself. Over the course of fifteen months, the British bands had helped secure the Grande's place on the ballroom rock circuit and raised its profile internationally. Rock music was making its profit potential known, and record companies, agents and concert promoters all wanted their piece of the pie. The year 1969 was one of significant change in the concert-promotion business as the whole industry shifted up a gear. As Gibb became more successful, he began to manage a number of acts. Traveling internationally to promote himself and his talent, Russ "shopped" his groups to record labels in London and crashed in the flats and manors of British stars like Eric Clapton, Steve Winwood and Mick Jagger.

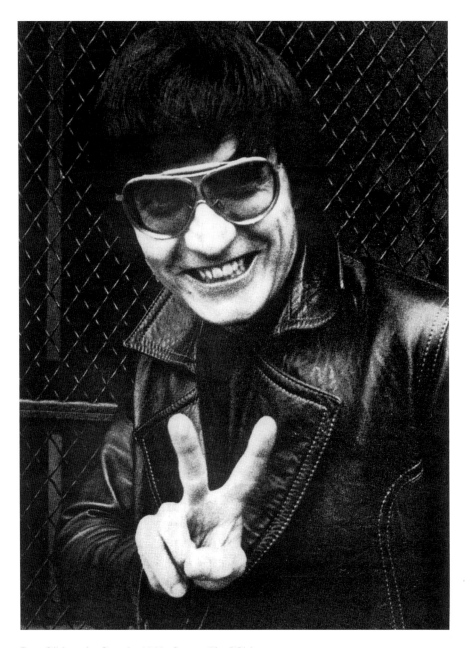

Russ Gibb at the Grande, 1969. *Courtesy Tom Wright.*

23
TOMMY

Pete Townsend and the Who had begun the writing and recording process for their rock opera, *Tommy*, in the fall of 1968. The next step involved touring to promote the record's release. Logically, they might have chosen the more proximal New York City and Bill Graham's Fillmore East as the starting point for their 1969 spring tour; however, Detroit and the Grande Ballroom offered better sound, bigger capacity and a much more appreciative trial audience. In mid-April, the *Detroit Free Press* spilled the beans: "Russ Gibb's been talking to Peter Townsend of The Who who will be at the Grande soon, Peter's wife just had a daughter and The Who may perform their new rock opera for the first time in the U.S. in Detroit."

Another benefit of the Grande was, of course, Pete's pal Tom Wright and his crew, now aptly named Hard Corps Productions. Before, during and after the three-night engagement, Tom and the Hard Corps arranged for the Who's accommodations. The band flew in a week early and used the time to rehearse in the empty ballroom. They fine-tuned a set that now included selections from the still unreleased LP. The single "Pinball Wizard," released on March 7, 1969, was all that American radio had at the time. To rectify this, Russ Gibb spun up his hype machine and invited Pete Townsend, who had brought with him advance acetates of the completed album, to "rap" about it on air at WKNR. *Tommy* would not be out until September, and the Who was previewing it to the world from Detroit, Michigan.

The Who shows of May 9, 10 and 11 broke all attendance records at the Grande, with well over 1,500 capacity-shattering fans attending each

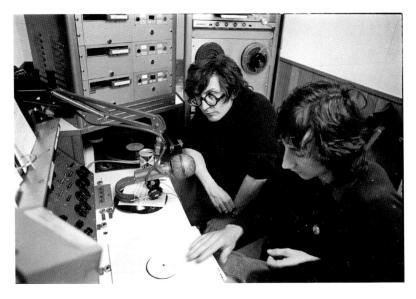

Russ Gibb and Pete Townsend playing advance copies of "Tommy" at WKNR studios in May 1969. *Courtesy Tom Wright.*

night. After Sunday's show, the crew threw a wrap party, complete with ice-cold beer in the stuffy air of the old dance hall. The band had gotten wind of the dozens of old roller skates that were still stacked six feet high in the basement. Pete Townsend commanded Wright, "Well?...Let's skate!"

In 2007, Wright shared a visual from the early hours of May 12 with the folks who turned out for his *Roadwork* book signing:

> *They turned on the strobe light and turned all the other lights out. And if you can imagine, Keith Moon heading up the skating party of people that hadn't been on skates in years, at full blast with a strobe light and Dave Miller yelling and playing Creedence Clearwater "Born on the Bayou." The last thing I remember, Keith, he was going about twenty miles an hour, went straight into the railing which he didn't know was there because the railing was black metal. It caught him right about here [points to his waist]. He did two or three flips and disappeared.*[67]

Since the Grande was not air conditioned and it was a warm spring night on the dance floor, some who attended this after party skate-athon have claimed that clothing was optional. Others recall it being Keith Moon's birthday. Keith Moon's actual birthday was August 23, 1946. The Who were never in Michigan for it, but then everyday was probably a birthday for Moonie.

24
EAST VERSUS WEST

In the spring of 1969, a twenty-year-old Greek immigrant and promoter from Dearborn by the name of Bob Bageris began putting on concerts at the 1,800-seat Eastown Theater at 8041 Harper Avenue, Detroit. On May 29, its grand opening, featuring SRC, Teegarden & Van Winkle, Savage Grace and Catfish, fired the opening salvo in a battle for the Detroit rock concert dollar.

On the Westside, Gibb and Glantz sprang into action and identified the Grand Riviera Theater, two blocks up Grand River from the Grande, as their answer to Bageris's invasion of the Motor City's live music market. They knew that Bageris and his Eastown, with a capacity greater than the Grande's, could afford to pay the higher guarantees bands were now demanding and even make a profit. Outdoor venues and disused movie palaces were one solution to fatter concert receipts. Glantz sought to negotiate a new lease deal.

The theatrical Nederlander family owned a number of theaters in both Detroit and New York City. In the early 1960s, their Riviera productions had moved to the family's new Fisher Theater operation on West Grand Boulevard. Glantz's fifteen-year-old employee Rick Lockhart recalled traveling with Gabe to Joey Nederlander's office in the Fisher building to pitch the deal for the Riviera. "It was like something out of a crime movie. We had to wait in the hallway, where two big burly Yiddish Jewish tough guys frisked us down. Then we walked down a hallway to meet Joey Nederlander. Mr. Nederlander asked who I was. Mr. Glantz said, 'The boy's with me. We

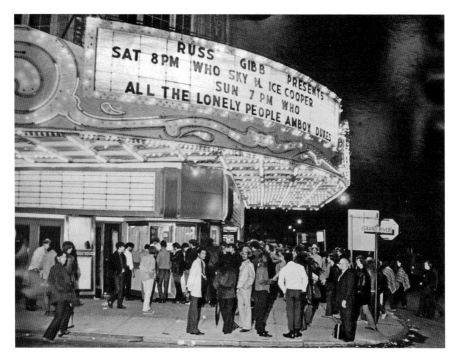

Grande Riviera Theater Marquee on opening weekend, October 11–12, 1969. *Courtesy Jeep Holland Papers, Bentley Historical Library, University of Michigan.*

can talk freely in front of him.' They talked a little in Yiddish, and about an hour later, it was agreed that we could take and use the movie theater."[68]

All of these grand plans and preparations drew some attention from outside parties. According to Rick Lockhart, Aaron Russo, owner-operator of the Kinetic Playground music venue in Chicago, arrived at the Grande Riviera one weekend:

> *There was a big stink over people from Chicago coming into the Grande wanting to take over because Detroit was so powerful and we were doing so well in the music scene. So these people came down to the Grande Riviera, and they said, "We are going to take over your music business." Mr. Glantz, who was up on the stage, kicked the guy [Aaron Russo] in the balls, guns were pulled. Mr. Glantz slapped him in the face and said, "Nobody's going to interfere with fucking music here in Detroit!"*

The Grand Riviera, now freshly rebranded the *Grande* Riviera, opened on October 11, 1969, with a triple bill featuring the Who, Alice Cooper

and Sky. The Eastown that weekend interestingly featured only local acts: Savage Grace, the Stuart Avery Assemblage, Carousel and Shiva. The schedules for the Riviera and the Eastown in this period show cooperation rather than competition between the two venues with respect to the acts that were booked: cheaper local acts on one end of town with a star headliner booked at the opposite end of the city. One theater often shut down lest it affect the draw at its crosstown "rival." Author David Carson, as well as *Creem* magazine, documented that Russ Gibb had considered purchasing the Eastown but backed out. Carson also noted that Aaron Russo was managing the Eastown for Bageris that fall.

On November 11, Mike Gormley revealed in the *Free Press* that Aaron Russo, his testicles now recovered, had apparently entered into a four-way partnership with Gibb, Glantz and Bageris. Russo's cooperation with the Eastown and the Grande Riviera may have been driven by some bridges he burned in the windy city:

> *I saw the Grande Riviera for the first time this weekend. It's not a bad place, as a matter of fact, compared to the old Grande it's heaven. I also met Aaron Russo, the new partner of Russ Gibb, and he seems to be a nice fellow. He also seems to be a man who takes charge. You could hear his voice emitting from his hairy head everywhere anytime something went wrong. Of course, it was his day for things to go wrong. Earlier in the day, his other place, the Kinetic playground in Chicago burnt to the ground.*

Rick Lockhart confirmed that the two sides of town had merged. With everything going on, the Grande Ballroom virtually shut down for the fourth quarter of 1969. The majority of the business that it conducted at that time was with local groups and fraternities interested in holding dance concerts. These were almost exclusively African American groups from the neighboring community. "We were renting out the Grande to black organizations who would put on a funk show or a fashion show. I would be the only white boy there!" Lockhart joked.[69] As these were semi-private events with no posters or advertising, they generally do not appear in contemporaneous accounts.

By early 1970, the east-west partnership had dissolved, with concerts ending at the Grande Rivera. Per the *Free Press* in 1975: "Bageris was ordered to pay the Glantzes $47,011 in damages for violating their 1970 contract." Bageris went on to a successful run at the Eastown through December 1971, when Mayor Gribbs shut him down for overcrowding, fire code infractions and drug violations. His Bamboo Productions thereafter became one of the most

successful concert promotion firms in the city, matched only by Steve Glantz productions. Both companies produced ever-larger events at major venues, including Cobo Hall, Ford Auditorium, Masonic Temple and Olympia. The shady dealings that had shadowed Bob Bageris at the Eastown continued to haunt him, however. In September 1974, the court charged Bageris with possession with intent to deliver 67.7 gram of cocaine; his conviction was handed down on October 1, 1975. That December, Bob was responsible for opening the Pontiac Silverdome with the Who, selling some seventy-six thousand seats, equivalent to fifty Grande Ballrooms. Bageris died in 1985 at age thirty-seven from a bone marrow disorder. Aaron Russo later managed Bette Midler and produced motion pictures like *Trading Places* and *The Rose*.

Part IX

CODA

By late 1969, Russ Gibb had largely separated himself from operations at the Grande, Grande Riviera and Eastown. He decided to get out of these smaller-tier venues when promoters got more competitive "and guns showed up." Instead, it was now possible to draw throngs of young people to ever larger and potentially more profitable outdoor events, like the massive Woodstock Festival of August 1969. That year, Russ began organizing regular festivals throughout Michigan, Ohio and Ontario. The famous Rock 'n' Roll Revivals at the Michigan State Fairgrounds featured some of biggest national acts and local groups.

25
GOOSE LAKE

Starting in earnest in 1969, Russ Gibb had promoted a large number of outdoor events in Michigan, Ohio and Canada. The three-day Woodstock Festival in Bethel, New York, that August set a precedent for size in these open-air venues. Russ saw that something comparable could be created in the Midwest, but he needed a secure sizable location. Woodstock's largest problem, apart from the weather, had been gatecrashers. Counterfeit tickets had become a problem as well. Early in 1970, Russ Gibb began working with developer Richard Songer on a solution, a secure, dedicated music festival park. Songer had been very successful in the construction business and had purchased some property in Leoni Township near Jackson Michigan. After defeating several lawsuits from neighbors and township residents, construction began. Songer's crews built speaker towers made of bridge steel and scooped out an earthen amphitheater. Tom Wright and his Hard Corps Productions helped design, build and run a rotating stage. Motorcycle clubs were employed for security, and a manufacturer in Las Vegas provided custom poker chips that were used for admission instead of paper tickets.

Over the weekend of August 7–9, 1970, 200,000 people showed up to see some twenty-three acts perform at the new Goose Lake Park. Bob Seger, Teegarden & Van Winkle, Mitch Ryder, the Stooges, the MC5, Detroit, Brownsville Station, Third Power and Savage Grace all represented the local acts. The James Gang, featuring Joe Walsh; John Sebastian; Ten Years After; Chicago; the Flying Burrito Brothers; and the Faces with Rod Stewart were among the star attractions. Unlike Woodstock, the Goose Lake International

Pop Festival was a much more organized and positive experience, thanks in great part to Tom Wright's production crew.

Despite its operational success, Goose Lake suffered from a lot of bad press surrounding the level of drug use at the event. This fueled legal initiatives from local residents and the State of Michigan that ultimately squashed Songer's dream of parlaying the festival into an entertainment/amusement park concern.

THE PEOPLE'S BALLROOM

In 1971, with the Eastown regularly in operation, the vast majority of the shows still put on at the Grande Ballroom were benefits or concerts put on by individuals who could afford the cash to rent the ballroom. These events generally contracted only local talent.

Many of these benefits were for John Sinclair's legal defense fund, with the promotional material referencing the "People's Ballroom." Arrested on a marijuana charge in 1969, Sinclair received a sentence of ten years in prison for giving two joints to an undercover officer. His release occurred shortly after his largest fundraiser, the John Sinclair Freedom Rally at Crisler Arena in Ann Arbor on December 10, 1971. John Lennon and Yoko Ono, Stevie Wonder and Bob Seger were some of the notables that performed.

Meanwhile, across town, Mayor Gribbs had finally managed to shut down the Eastown that month for overcrowding, fire code infractions and drug violations.

The year 1972 saw events at the Grande Ballroom promoted by a John Salvador and a number of other young entrepreneurs. Gabe Glantz and his twenty-one-year-old son, Steve, soon took note of their success, and Steve started promoting shows of his own. Frank Bach, in the *Ann Arbor Sun* noted, "Salvador found his rental fees being raised each time he put on a concert, and Steve Glantz had soon reserved all the best concert dates—New Year's, Halloween, etc. for himself. Frustrated at the Grande, Salvador and friends moved to the Eastown where they soon met resistance from the neighbors who thought they were the same promoters who had ruined the Eastown's reputation in the first place."

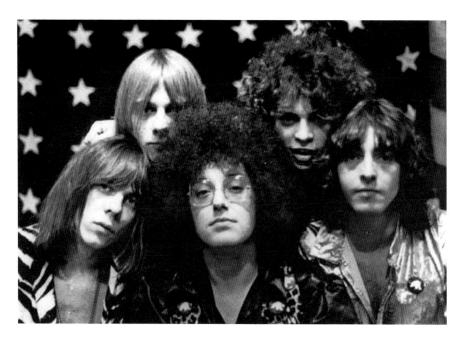

An MC5 promotional photo, circa 1968. *From left to right*: Fred Smith, Dennis Thompson, Rob Tyner, Wayne Kramer and Michael Davis. *Courtesy Leni Sinclair.*

Therefore, it was Steve Glantz who hired the MC5 to play their final show at the ballroom. The band, motivated by a $500 payday, agreed to perform for an anemic New Year's Eve crowd of perhaps 250 kids. Beleaguered by substance abuse problems and mismanagement, the group virtually crumbled on stage, with guitarist Wayne Kramer departing halfway through their show.

The MC5's final performance ushered in the New Year and rang the closing bell for the Grande Ballroom. Just twenty-seven days before, on December 4, Mayor Roman Gribbs had dedicated the new section of the Jeffries Expressway that now ran from the Ambassador Bridge to just beyond Livernois Avenue. The roadway bisected entire neighborhoods and shunted business to the suburbs. Traffic disappeared from Grand River.

Although the hall was rented throughout 1973 and 1974, few artifacts remain, as they appear to have been mostly private or poorly advertised events. Glantz was happy to have a few customers, as they covered the utilities and kept the pipes from freezing. Glantz and his son had turned their attention to other, larger venues and opportunities. They were apparently open to offers to purchase the ballroom, as Michael Keener, an investor/promoter who had worked with Mike Quatro and Russ Gibb, appears on the real estate record for 8952 Grand River.

POST 1972

THE MICHIGAN PALACE

A local doctor named Leo Speer had experience owning and operating a couple of successful Westside rock clubs by 1973. His Funny Farm in Wayne and the West Side 6 in Detroit regularly did banner business. Speer bought the operating lease for the Michigan Palace, a failed supper club that had been operating out of the magnificent Michigan Theater. At the time, the palace's lease cost Speer less than the bank note on one of his small lounges.

Gabe Glantz had been defending promoter John Salvador in his license fight to keep his schedule of concerts at the Showcase Theater (Eastown). He knew his client was considering the Michigan if the Showcase effort failed. When the courts ruled against Salvador, Glantz immediately engaged Speer with an offer he could not refuse. Speer agreed that Glantz would provide both capital and contacts to put on large-scale rock shows for his venue. Soon, the pair, along with their sons Steve Glantz and Benny Speer, incorporated as the Michigan Palace and began to put together a season for the 4,500-seat ornate landmark. Russ Gibb, as a favor to Speer, showed up to inspect the property and told Leo, "You guys gotta get this band called the New York Dolls," recalled Benny Speer. Sure enough, the grand opening with the Dolls at the Michigan Palace had lines around the block, and good old Uncle Russ received a finder's fee. Over the next couple of years, the partners hosted everyone from Linda Ronstadt to Z.Z. Top and the Stooges to David Bowie.

The shows held at the Michigan Palace provided good training and an income for Gabe's son Steve Glantz. Steve had been in the business since the days of taking tickets and ejecting stoned concertgoers down the stairway at the Grande. He had now become a sizable player in the Detroit market, putting on shows at many of the larger properties. In March 1975, the *Free Press* reported, "When the subject of Detroit area rock promoters comes up, the discussion is likely to be short, it will start with Bob Bageris of Bamboo Productions and end with Steve Glantz of Steve Glantz Productions and Michigan Concert Palace Inc."

Steve even helped break shock rockers Kiss in Detroit, with shows at the Michigan and Cobo Hall. Bob Seger's monster *Live Bullet* LP recordings in September 1975 were from two Glantz-produced shows. After roughly a two-and-a-half-year run, the Michigan Palace collapsed in a hail of lawsuits, and the partners moved on.

By 1998, Gabe Glantz had retired and was closing million-dollar real estate deals in Broward County, Florida. His youngest son and protégé, Steve, after winning and losing several fortunes in the promotion game, sadly took his own life at age fifty. Today, the once proud Michigan is a converted parking garage; the only sounds echoing there are the squeals of car tires and the fluttering of pigeons.

By 1976, Russ Gibb, largely out of the promotion game by this point, was advising senators in Washington, D.C., on youth education for the bicentennial. He consulted with politicians on education reform and on disposing of the marijuana plants they found growing in their Georgetown backyards. An acknowledged expert on the youth of the day, he even broke bread with Jimmy Carter at the Allman Brothers' annual picnic in Macon, Georgia. After a short tour as a consultant, he had returned to his hometown of Dearborn, Michigan, by 1977.

Russ had used closed-circuit TV technology while renting Mick Jagger's Stargroves estate during a British vacation in 1969. That same technology was what made cable TV possible. His accountant recommended that he purchase the rights to cable for Dearborn when they became available in the early 1970s. The mayor of Dearborn laughed when Russ and his partner made the purchase, saying, "Who would want to buy something you can get over the air for free?" Evidently Westinghouse of New York did, a scant few years after Russ's initial investment. Westinghouse wanted to wire up Dearborn, and soon Russ and his partner Michael Berry were flown to Westinghouse Corporate Headquarters in New York by private jet. After a brief negotiation, they each left with seven-figure checks from the Group

W cable division. Though Russ certainly could have retired, he returned to teaching media arts at Dearborn High School in a fully equipped media and television lab, a facility funded by an endowment he created after the Westinghouse sale. For every one hundred kids who passed through the Grande or went to one of Russ's concert productions, there is one who went through his acclaimed Dearborn High video program.

28

THE GOD SQUAD

Hello Jesus
Jesus children
Jesus loves you
Jesus children
Hello children Jesus loves you of America
"Jesus Children of America," by Stevie Wonder, copyright 1973

The Grande Ballroom, rarely open for private events from 1973 to 1975, witnessed a period where the building changed hands quickly from the Glantz family to promoter Michael Keener and then, ultimately, to a series of churches.

JESUS PEOPLE

In the late 1960s and early '70s, a version of Christianity called the Jesus Movement swept North America. In 1971, a Pentecostal preacher from Mount Clemens by the name of George Bogle brought his House of Prayer to Detroit, opening up a coffee complex at 8661 Grand River. Also known as Jesus People or Jesus Freaks, their parent Evangel Echoes Church of the Air appears on the real estate records in 1976 at 8952 Grand River. Neighbors and church members have recalled the Grande building all spruced up and holding services like weddings and broadcasts of Bogle's *Ministry of the Air*

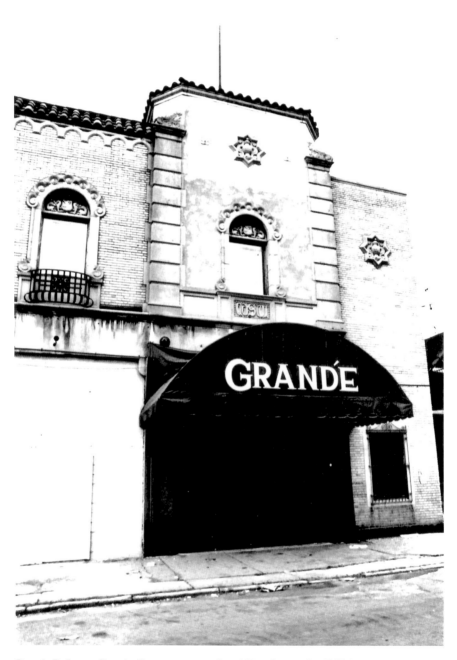

Grande Ballroom Beverly Court marquee, circa 1975. *Courtesy David Hichman.*

radio show. Rock hymns were part of the House of Prayer scene, as were Bible studies, renamed "rock raps." Teri and Tom Lewandowski were one couple who made memories at the Grande. Teri Coloske (ex. Lewandowski) shared with thegrandeballroom.com guestbook, "My now ex-husband and I were married by Pastor George Bogle in the Grande Ballroom on December 10, 1977. Pastor Bogle did a beautiful job restoring it."[70]

CITY TEMPLE

It appears that the Seventh-Day Adventist City Temple Church at 8816 Grand River purchased the Grande building at auction in the late 1980s or early '90s. A couple of small gatherings and a soup kitchen utilized the second floor, but neither tenants nor further investment in the building materialized.

FUTURE HOME OF...

Pastor Roy A. Allen Sr. and his Chapel Hill Missionary Baptist Church congregation moved into their newly built facility at 5000 Joy Road in October 1967. In 1996, the reverend Dr. R. LaMont Smith II ascended after Pastor Allen's retirement. In 2006, Reverend Smith and CHMBC purchased the Grande Ballroom building from the Seventh-Day Adventist City Temple church for a price purported to be in the low five figures. The congregation painted a large mural on the Grande with the words "Future Home of the Chapel Hill Missionary Baptist Church" emblazoned on it.

29

KNIGHTS, FRIENDS AND SCRAPPERS

JEFF VAIL AND THE KNIGHTS OF THE GRANDE

In 2003, Jeff Vail, a drummer who played in a number of Grande bands, formed the Knights of the Grande Benevolent Corporation. Working with artist Howard Fridson and musicians Ray Goodman (SRC), Stoney Mazar (Jagged Edge) and Jem Targal (Third Power), Vail launched a series of concerts benefiting Grande musicians and their children who were in need of financial help. Their largest production was a September 24, 2005 show at Masonic Temple's Crystal Ballroom with Mitch Ryder and Dick Wagner (previously of the Frost) as headliners. After Vail passed away, the Knights' last benefit on March 25, 2006, in Royal Oak was for Jeff's kids' college fund.

Jeff Vail's Knights of the Grande logo. *Courtesy Howard Fridson.*

THE FRIENDS OF THE GRANDE

Spun from visitors to thegrandeballroom.com, the Friends of the Grande organized as an informal grass-roots group in January 2006 with the following mission statement: "To preserve the history of the Grande Ballroom and its physical edifice while promoting the Culture fostered by its patrons, performers and promoters."

The group put forth three objectives:

1. Preservation: To investigate the viability of stabilizing, preserving and restoring the Grande building.
2. Nomination: To nominate the building for inclusion on the National Register of Historic Places.
3. Celebration: To mark the fortieth anniversary of the rock reopening of the Grande.

The Grande sold unexpectedly to Chapel Hill Missionary Baptist Church as the Friends of the Grande, or FOG, sought a purchase agreement with the current building owners, the Seventh-Day Adventists. Shelved were the plans to pursue the preservation objective and to incorporate as a nonprofit.

Pursuing the celebration objective, FOG members Tom Gaff and Tom Lubinski incorporated as Old Stoners Productions for the purpose of creating a Fortieth Anniversary Concert. On October 7, 2006, Old Stoners staged such a concert at the Royal Oak Music Theater featuring Third Power, Arthur Brown, Canned Heat and Big Brother and the Holding Company. Each of these acts, which all had appeared at the original Grande, performed once again to a full house. The guest of honor, Russ Gibb, received a large brass plaque of appreciation. Tom Wright, critically important to the Grande's success, also made an appearance.

In 2007, with help from architect Rebecca Binno Savage, I pursued the group's outstanding objective, historic nomination. As part of the application for inclusion on the National Register of Historic Places, the team presented the Grande's Historical significance to the State Historic Preservation Office in Lansing. The process also required that the City of Detroit's Historic District Advisory Board approve the Grande property. At the September 13, 2007 meeting of the board, more than twenty members of the Chapel Missionary Baptist Church, the building's new owners, appeared for public comment. Reverend Smith and the church asked the board for more time to investigate the proposal. The board tabled the Grande nomination. Since

"Uncle Russ Loves You" Grande Ballroom Fortieth Anniversary Concert postcard, 2006. *Art by Carl Lundgren.*

2007, CHMBC has not invested in the Grande property as planned or allowed for historic nomination. Since owner approval is required for the historic registration process, this objective has not come to fruition.

SCRAPPIN' SOUVENIRS

In the years since the turn of the century, after the Seventh-Day Adventists utilized the Grande as a soup kitchen, the building has been prone to theft and vandalism. In the last two decades, scrap metal prices made certain that anything that a magnet stuck to disappeared from the old hall. All of its owners since the 1970s, not having budgets to secure it properly, also saw souvenir hunters trespassing through the building regularly. Those who did venture inside either passed through reverently or selfishly and pragmatically took themselves home a piece of the Grande, one chunk at a time. Steel vent caps, long ago pilfered, created a conduit for rainwater to flow into the building and wash away much of the plaster below. Its deteriorating condition was what some called "demolition by neglect." In fact, the building has had plenty of attention; unfortunately, most of it has not been of the constructive type. The once proud ballroom matched some the finest movie palaces of the 1920s.

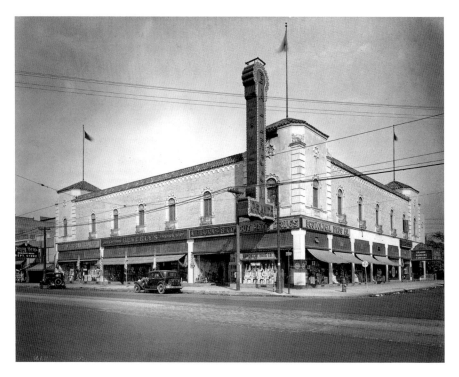

The Grande Ballroom, October 19, 1929. *From the Manning Brothers Historic Photographic Collection.*

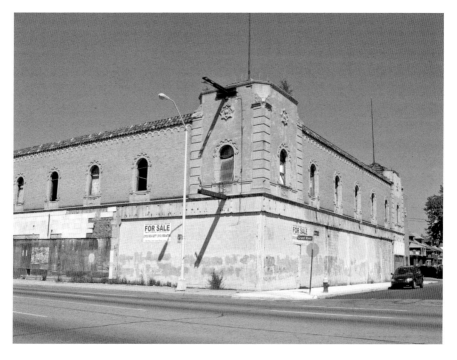

The Grande Ballroom, circa 2005. *Author's collection.*

Today, it is a building perforated by theft and left open to the elements. Although out of mind to most, there are many who have not forgotten.

GRANDE BALLROOM PERFORMERS LIST (1966–1972)

Aaggons

Aere Apparent

Air Speed Indicator

Albert King

Allen Ginsberg

All the Lonely People

The Amboy Dukes

The Apostles

Apple Corps

Apple Pie Motherhood

Armada

Arthur Brown

The Ashmollyan Quintet

Asian Flu

The Assemblage

The Attack

The Back & Back Boo
 Funny Music Band

Bad Manners

Ball

Ballin' Jack

Barbara Holliday

The Barons

B.B. King

Beacon Street Union

Bedlam

The Belshires

The Berry Patch

The Bhang

Big Brother and the
 Holding Company

Billy C. & the Sunshine

The Bishops

The Black & Blues Band
Black Pearl
Blackstone Row
Blackwood Drake
Blood Sweat and Tears
Blue Cheer
Blue Oyster Cult
The Blues Confederation
Blues Train
Bo Diddley
Born Blues
The Bonzo Dog Band
The Bossmen
Brand X
Brat
Brian Auger & the Trinity
Brownsville Station
The Buckingham 5
Buddy Guy
Buffy Reed Phenomena
The Bump
The Buoys
The Butterfield Blues
 Band
The Byrds
Canned Heat
Captain Beyond
Carousel
The Case of E.T. Hooley
Caste
Catfish
Certified Chalk Cyrcle
The Chambers Brothers
Changing Times
Charging Rhinoceros
 of Soul
The Charles Moore
 Ensemble
Charlie Musselwhite
The Children
The Chip Stevens
 Blues Band
The Chosen Few
Chrysalis
Chuck Berry

Churls
City Limits
Clear Light
Colosseum
The Coming
Commander Cody & His
 Lost Planet Airmen
Commander Cody & His
 Swing Band
The Cosmic Expanding
 Blues Band
Country Joe & the Fish
Cowardly Thangs
Crabby Appleton
Cradle
The Craig Sutherland
 Movement
The Crazy World of
 Arthur Brown
Cream
Creedence Clearwater
 Revival
C-Water Blues
Dave Workman Band
December's Children
Deep Purple
Detroit
The Detroit Blues Ball
Detroit Edison White
 Light Band
Dharma
Dick Purtan
Dick Rabbit
The Dogs
Dorian Coste
Dr. John
The D.S.R.
Earth Opera
Eastside Orphans
Ebony Tusk
The Eccentrics
Echoes from a Broken
 Mirror
The Electric Prunes
Elton John

The English Ryders
The Epidemic
Eric Burdon & the Animals
The Euphonic Aggregatio
Faith
Family
The Family Medicine
 Chest
The F.D.A.
Fever Tree
The Flamin' Groovies
Fleetwood Mac
Floating Circus
The Flow
The Flower Company
Fox
Frank Zappa
Frick
Frijid Pink
The Frost
Frozen Sun
The Frut of the Loom
Fuchia
The Fugs
The Gang
Genesis
Geyda
Girls Inc.
Gold
The Gold Brothers
Golden Earring
The Grateful Dead
Green Grass Blues
The Group
Guardian Angel
Hamilton Face
Happiness Tickets
Harmond Street Blues
The Harvard Street Blues
Harvey Khek
Hawk
The Heard
The Henchmen
The Hideaways
The Hitchhikers

Holy Ghost
The House of Lords
Howlin' Wolf
H.P. & the Grass Roots
 Movement
Influence
Iron Butterfly
Iron Horse Exchange
It's a Beautiful Day
The Jagged Edge
Jam Band
The James Cotton
 Blues Band
The James Gang
Jameson Roberts
The Jazz Disciples
The Jeff Beck Group
Jefferson Airplane
Jethro Tull
Jett Black
The J. Geils Band
Joe Cocker & the
 Grease Band
John Drake's Shakedown
John Mayall
Johnny Winter
Jonathan Round
Joseph Jarman & the
 English-Spangler
 Jazz Unit
Joust Limited
Joyful Wisdom
Julia
Junior Wells
Justice Colt
Keef Hartley
Kensington Market
King Crimson
The Kinks
The Kynde
The Landeers
The Lawrence Blues Band
Led Zeppelin
Lee Michaels
Lightnin'

Linn County
The Litter
Little Sunny
Livonia Tool & Die
 Company
London Fog
The Lost Generation
Love
The Lyman Woodard
 Ensemble
The Lyman Woodard Trio
Maend
The Malibus
Man
Manchild
Marble Orchard
The March Brothers
The Maxx
Mccoys
The MC5
McKenna Mendelson
 Mainline
The Metrics
The Mind Machine
Mixed Generation
Moby Grape
The Moody Blues
The Morticians
Mother Earth
Mother's Little Helpers
The Mothers of Invention
The Motor City Mutants
The Move
Mr. Stress Blues Band
Muff
Mylon
Mystery Bands
Natures Children
New Phenomena
The New Spirit
The New York Rock N
 Roll Ensemble
The Nice
Nickel Plate Express
Nirvana

Oaesse
Odds & Ends
Ohio Power
One Way Street
Open Jam
Orange Fuzz
Our Mother's Children
Ourselves
Pacific Gas & Electric
The Pack
Panic & the Pack
The Passing Clouds
The Paul Butterfield
 Blues Band
The Paupers
The Peanut Butter
 Conspiracy
Pegasus
Pentangle
People
Period
Peter Max
Phenomena
Phil Ochs
The Phogg
Piers
Pink Floyd
The Plague
Plain Brown Wrapper
Poison Oak
Poor Richards Almanac
Poor Souls
Popcorn Blizzard
Pride
The Primates
The Prime Movers
Procol Harum
Proud Flesh
The Psychedelic Flipout
The Psychedelic Lollipops
The Psychedelic Stooges
Quicksilver Messenger
 Service
Rain
Rare Earth

The Rationals
The Raven
The Reason Why?
The Red, White &
 Blues Band
The Restless Set
Richmond
Riff
Rodney Knight
The Rotary Connection
Roy Buchanan
RPM
The Rumor
Rush
Sabbath Opera
Sand
Savage Grace
Savoy Brown
Scot Richard Case
Seventh Seal
Shadowfax
The Shaggs
Shakey Jake
Shifting Sands
Shiva
Side Pair
Sixth Street
Sky
Slim Harpo
Sly and the Family Stone
Soap
Soft Machine
Somethin' Else
Sons of Sound
Soul Remains
Southbound Freeway
The Southampton Rowe
The Spike Drivers
Spirit
Spooky Tooth
SRC
Steppenwolf
The Steve Miller Blues
 Band
Still Eyes

St. Louis Union
The Stooges
The Strange Fate
The Stuart Avery
 Assemblage
Suburban Roots
Sum Guys
Sun
The Sunday Funnies
Sun Ra
Surprise Goodies
Sweathog
Sweetwater
Sweet Wine
The Taboos
Tacklebox
Taj Mahal
Target
The Tate Blues Band
The Tea
Ted Lucas
Teegarden & Van Winkle
Ten Years After
Terry Reid
The Third Power
Thomas Blood
Those Guys
Three Dog Night
Thundercloud
The Thyme
Tiers
Tiffany Shade
Tim Buckley
Tim Kaye
Toad
Toby Wesselfox
Traffic
The Train
The Trees
The Tribal Simphonia
The Troggs
The Troyes
The Trunion Brothers
T-Rex
The Turtles

The Uncalled Four
The Unrelated Segments
The UP
The Up-Set
Vanilla Fudge
Van Morrison
The Velvet Underground
The Vernor Highway
 Blues Band
The Village Beaus
Virgin Dawn
The Walking Wounded
Washing Machine
Wayne Cochran
The Weeds
The Werks
We Who Are
Wet Nasteez
The Wha?
The Whiz Kids
The Who
Wicked Religion
The Wild Cargo
The Wild Woodies
Wild Yam Rama Chuck
 Band
The Wilson Mower
 Pursuit
The Wind
The Woolies
The Yardbirds
Yesterday's Shadows
Youngbloods
The Zymodics

NOTES

1. Charles Agree, interview by Greg Piazza, Charles Agree home, April 1980.
2. Ibid.
3. "New Apartment Hotel Near Masonic Temple," *Detroit Free Press*, June 6, 1926, 77.
4. Agree, interview.
5. Ibid.
6. Clem Weitzman, interview by the author, West Bloomfield, Michigan, June 15, 2007.
7. Ralph Bowen, telephone interview with author, March 1, 2007.
8. Ibid.
9. Jim Pudjowski, telephone interview with author, August 13, 2014.
10. Ibid.
11. Ray Salinas, telephone interview with author, August 13, 2014.
12. Jim Dunbar, telephone interview with author, August 7, 2014.
13. Leni Sinclair, telephone interview with author, June 6, 2010.
14. Ibid.
15. John Sinclair, interview by author, Avalon Bakery, Detroit, July 7, 2005.
16. Leni Sinclair, telephone interview.
17. John Sinclair, interview.
18. John Sinclair, "Grande Days: Detroit's Fabulous Grande Ballroom 1966–1972," John Sinclair Online, January 29, 2006, http://johnsinclair.us/index.php?option=com_content&task=view&id=728&Itemid=2.
19. Leni Sinclair, telephone interview.
20. Ibid.
21. Ibid.
22. Gary Grimshaw, telephone interview with author, December 29, 2009.
23. "Teen Dances Banned," Detroit Free Press, June 16, 1966, 3.
24. John Sinclair, interview.

25. Steve Finly, e-mail message to the author, July 18, 2013.

26. Frank Bach, interview by the author, Detroit, Michigan, July 31, 2008.

27. Steve Kott, interview by author, Miller's Bar, Dearborn, Michigan, October 20, 2010.

28. Clyde Blair, interview by author, April 29, 2015.

29. Tom Gaff, interview by author, Grande Ballroom, March 12, 2005.

30. Jem Targal, telephone interview with author, September 9, 2006.

31. Drew Abbott, telephone interview with author, September 1, 2006.

32. Dan O'Connell, "The Wha?," Dumpster Designs, accessed July 5, 2015, http://www.dempsterdesigns.com/music/thewha.shtml.

33. Leni Sinclair, telephone interview.

34. John Sinclair, interview.

35. Michael Erlewine, telephone interview with author, May 8, 2016.

36. Wayne Kramer, interview with author, July 7, 2006.

37. Geoffrey Fieger, interview by Jason Schmitt, October 18, 2008.

38. Carter Collins, telephone interview with author, February 5, 2010.

39. Bach, interview.

40. "44th Anniversary of the the [sic] Exorcism of the Pentagon," *Dangerous Minds*, October 17, 2011, http://dangerousminds.net/comments/44th_anniversary_of_the_the_exorcism_of_the_pentagon.

41. Jim McCarty, telephone interview with author, August 4, 2014.

42. John Sinclair, interview.

43. Rick Patrny, telephone interview with author, March 18, 2015.

44. Rick Lockhart, telephone interview with author, November 15, 2007.

45. Carl Lundgren, interview by the author, Addison Apartments, November 26, 2008.

46. Paul Vitello, "Frank Barsalona, Rock 'n' Roll Concert Promoter, Dies at 74," *New York Times*, November 29, 2012, accessed June 18, 2015, http://www.nytimes.com/2012/11/29/arts/music/frank-barsalona-rock-n-roll-concert-promoter-dies.html?_r=0.

47. Dave Miller, telephone interview with author, April 20, 2016.

48. Dick Wagner, interview by the author, Red Roof Inn, Madison Heights, Michigan, November 7, 2011.

49. Ibid.

50. Russ Gibb, interview by the author, Gibb mansion, April 2, 2006.

51. Jem Targal, telephone interview with author, September 9, 2006

52. Ibid.

53. "Bob Seger," *Jim Johnson Show*, WCSX, October 1, 2006.

54. John Sinclair, interview.

55. Ibid.

56. Patrny, telephone interview.

57. Ibid.

58. Gibb, interview.

59. Ruth Hoffman, interview by Jason Schmitt, October 18, 2008.

60. Ibid.

61. Ibid.

62. Tom Wright, telephone interview with author, September 18, 2008.

63. Ibid.

64. Don Was, interview by Jason Schmitt, July 20, 2008.

65. John Sinclair, interview.

66. Rick Clark, "Classic Tracks: The MC5's 'Kick Out the Jams,'" Mixonline, March 1, 2003, http://www.mixonline.com/news/profiles/classic-tracks-mc5s-kick-out-jams/365187.

67. Tom Wright, Roadwork book signing, Borders Books, Novi, Michigan, 2007.

68. Lockhart, interview.

69. Ibid.

70. Grand Ballroom guestbook, "Teri Coloske says…," December 22, 2012, http://thegrandeballroom.com/guestbook-2.

INDEX

ABOUT THE AUTHOR

Leo Early is an author, musician, historian and preservationist. He enjoys researching and writing about Detroit history, focusing especially on Detroit's rise and reputation as a music capital. In 2003, Leo launched TheGrandeBallroom.com to share his research, and the result was an unexpected groundswell of interest in the ballroom. Early has since met and corresponded with many who experienced the Grande firsthand and, in so doing, has inadvertently become a subject matter expert on this building, a nexus of Detroit music.